SACRED ART

Create your own spiritual and mandala art
with easy acrylic painting techniques

KATHLEEN HOFFMANN

DAVID & CHARLES

www.davidandcharles.com

CONTENTS

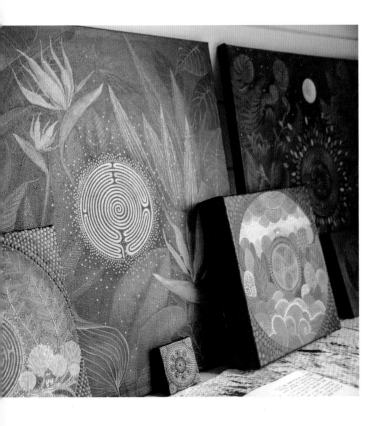

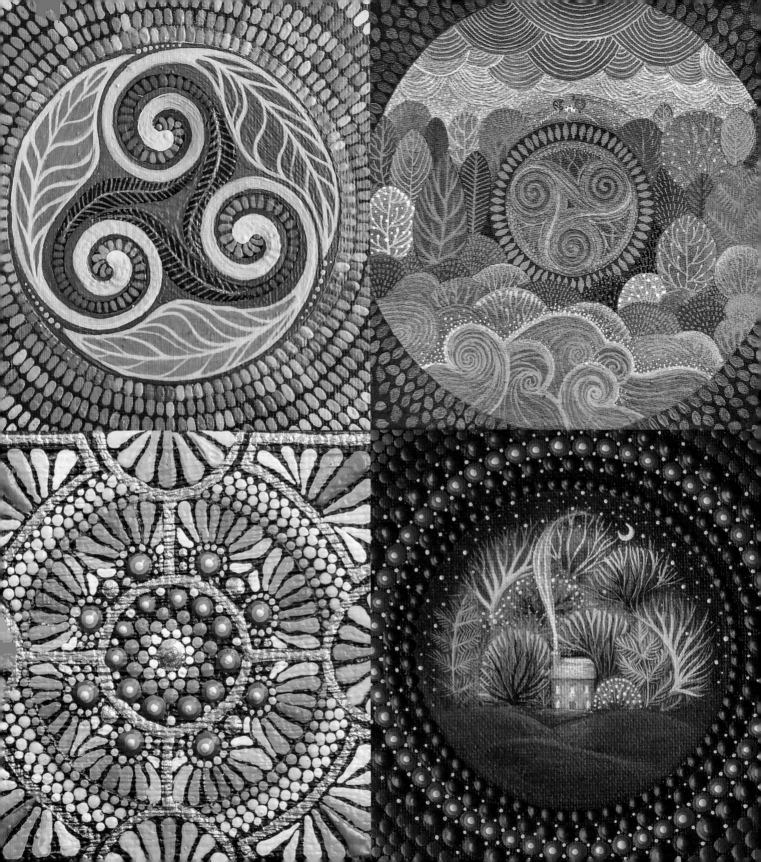

FOREWORD

My name is Kathleen Hoffmann, and I am delighted that this book has found you. In this book, I'd like to share my passion for both painting and mandalas with you. To do this, I've compiled a selection of my paintings to give you a detailed insight into the creative process using photos and step-by-step instructions.

I'll take you through the basic techniques and then I'll show you new design elements within each project, as well as how I use colours and composition.

This book is intended as a creative toolbox that you can then use to create endless variations of your own mandalas.

I want to do more than share tips and techniques with you though. What really drives me in my artistic work is the fascination of finding all of nature imbued within one geometric creative force. From the spiral growth pattern of a fern and the branching system of trees to the symmetry in leaves and flowers, these principles are found in every part of nature, no matter how complex or simple something is.

This observation confirms to me that everything is interconnected and follows universal principles. Symbols have reflected this since time immemorial, and are found in every culture in the world. That is why symbols – such as the triskelion or the labyrinth – are recurring elements in my pictures.

As an illustrator, I particularly enjoy weaving story-telling moments into my pictures. Suddenly a window is opened into another world: a smoking chimney is hidden amongst the treetops or a white cat lures you into a mysterious garden. These moments lead you into a fantasy world that encourages you to pause and dream.

I would like to invite you to connect with the power of nature and symbols, and to discover and explore the endless variety of these structures as you draw, and to develop this beauty in your pictures.

I would be absolutely delighted to accompany and inspire you on your creative journey and I look forward to seeing your creations! Feel free to tag me using **@kathleenhoffmannart** or the hashtag **#kathleenhoffmannart** on Instagram.

With sunny greetings,

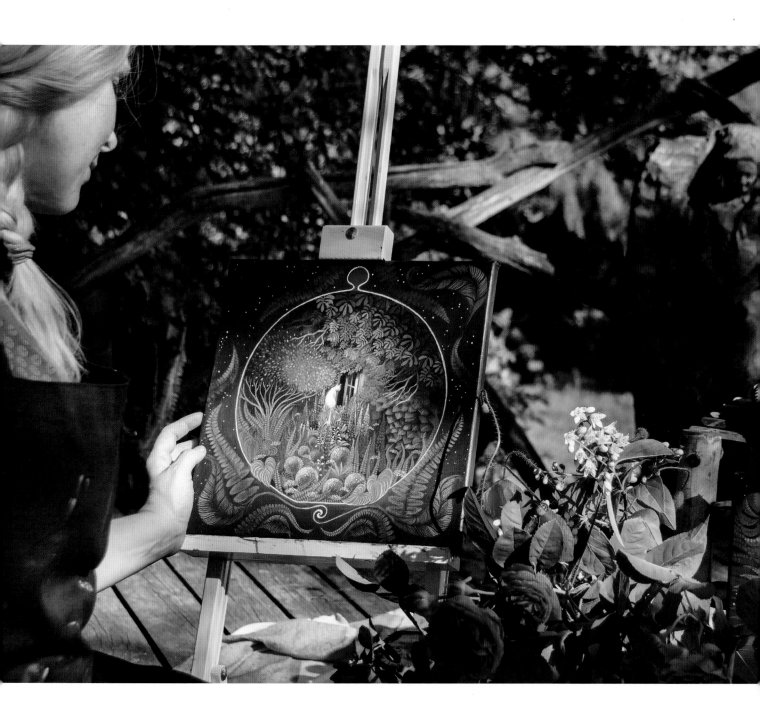

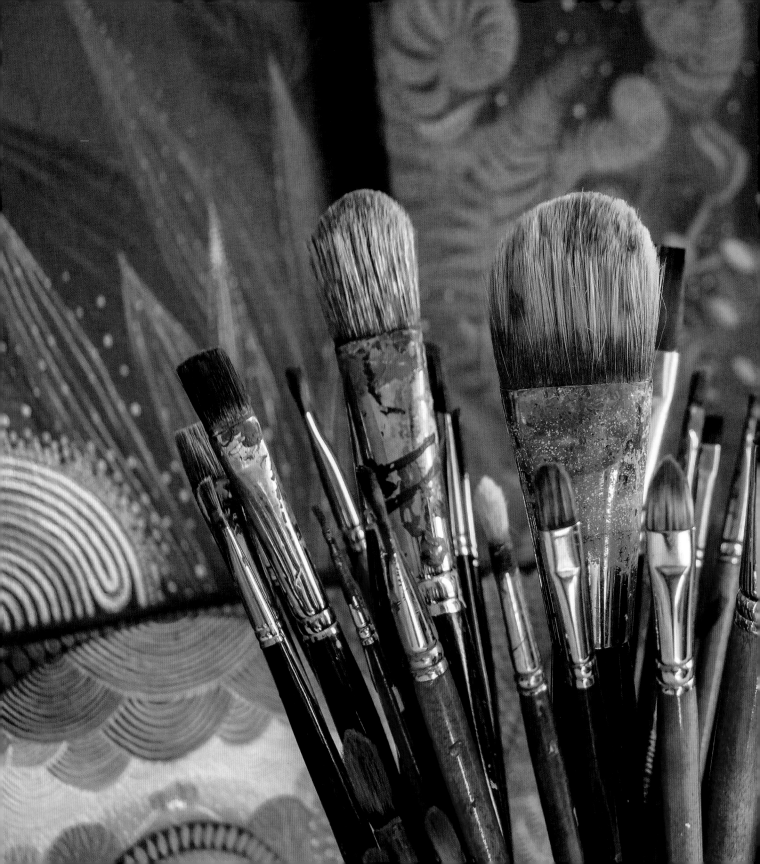

BASICS

MATERIALS

In this section, I will share information about the materials I use and what you will need to create the projects in this book.

ACRYLIC PAINTS

I like using acrylic paints because they are so uncomplicated and versatile. Unlike oil paints, they can simply be diluted with water. Thinly diluted, they can be used as a glaze and to create fine, delicate colour progressions. Used as a paste, the colour can be applied more generously. Acrylic paint dries quickly, and you can keep applying new layers of paint, either transparently or with full coverage, to a dry layer. This makes corrections easier and the painting process is very easy to control. This is why acrylic paints are ideal for beginners in particular, as it means they can focus on the actual painting rather than worrying about making mistakes.

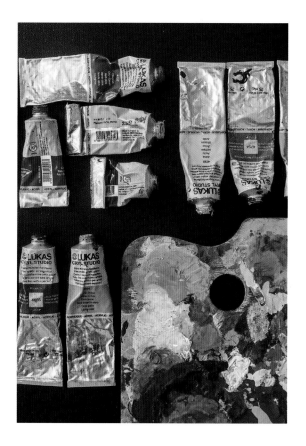

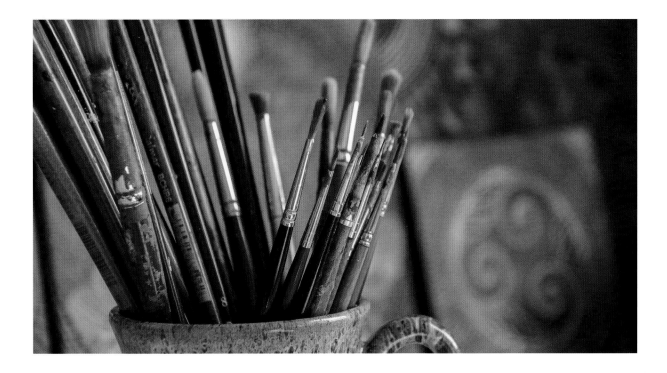

BRUSHES

Before I talk about the different shapes of brushes that you can get, note that there are two types of brushes: those with bristles made of real hair, and those with synthetic bristles. Brushes made with real hair are much more expensive, and usually have names like Kolinsky or Sable. The hair is often obtained from the fur industry and made in countries such as China or Russia. I always use synthetic brushes so no animals have to suffer needlessly. This information will be available at art shops, where you will also find a large selection of high-quality synthetic brushes. They are also easier to look after and stronger, especially if you are using them with acrylic paint.

Tip

Once dry, acrylic paint is as difficult to wash out of clothes as it is out of brushes. So choose your painting clothes carefully. I have "enhanced" more than one much-loved garment unintentionally with bright splashes of paint. It's obviously a good idea to wear old clothes or an apron when painting.

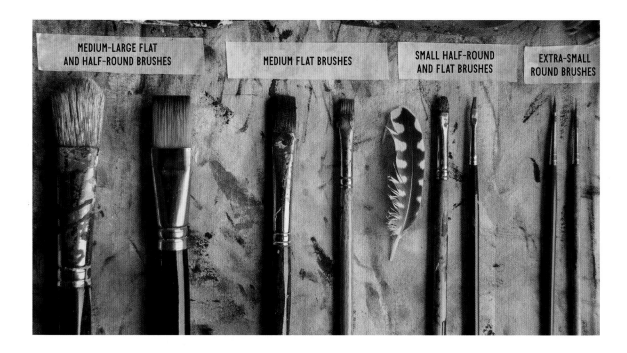

MEDIUM-LARGE FLAT
AND HALF-ROUND BRUSHES

MEDIUM FLAT BRUSHES

SMALL HALF-ROUND
AND FLAT BRUSHES

EXTRA-SMALL
ROUND BRUSHES

Brush shapes

I use round and flat brushes. You can also buy rounded versions of flat brushes, such as the cat's tongue brush. Flat brushes are usually used for large, even strokes and also for applying glaze. I use round brushes in the smallest sizes for fine details and dotting.

Choose the size of brush to suit the format that you will be painting on. Over time, you will develop a preference for your brush's level of hardness. This will depend entirely on your painting style and your preference. It's a good idea to try a number of brushes and decide which one you like using the best.

Caring for your brushes

When you have finished painting, don't let the paint dry on your brushes but clean them promptly. It's almost impossible to get dried acrylic paint out of brushes. Don't leave your brushes standing in water overnight either, but carefully pat them dry and place them on a piece of fabric to dry. If you'd like to give your brushes a little extra care, you can buy proper brush cleaning products from an art shop. They will keep the bristles nice and soft, they smell lovely and are safe for the environment. It is important not to leave damp brushes to dry with the tip pointing upwards, as this will allow the moisture to penetrate the ferrule (connecting the brush head to the handle) and shorten the brush's lifespan.

CANVASES

You can buy very good stretched and primed canvases from an art shop, choosing between coarse or fine fabrics. I generally prefer to work with very fine details on smaller formats, so I usually opt for finer fabrics. Well-stretched canvases will not be distorted by the moisture in the paint. They are strong, durable and light, which makes them perfect for acrylic painting.

YOU'LL ALSO NEED

→ Spray bottle
→ Tumblers or beakers (ideally two)
→ Palette knife
→ White pencil
→ Circular templates or compass
→ Ruler
→ Eraser
→ Varnish with UV protection

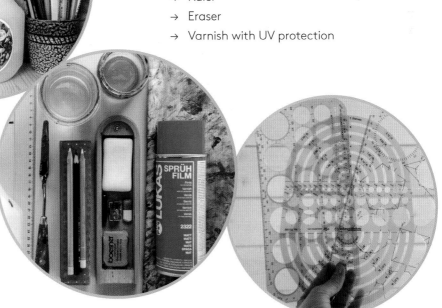

TECHNIQUES

In this section, I will explain how to construct my favourite symbols, the triskelion and the labyrinth; how best to mix colours and use the dot painting technique; and why a sketchbook is such a valuable tool.

MIXING COLOURS

I use a white plate to mix my colours. A neutral white background is more useful when judging a mixed colour than a wooden palette. I like to use a spray bottle (1) for diluting. I find this is the best way to measure out the water and achieve the right consistency. It's also a good way to moisten a mixed colour if it starts to dry. For mixing colours, I use a narrow palette knife (2 and 3) because precious brushes are much too valuable to be worn down by frequent stirring, plus the hairs or bristles can break.

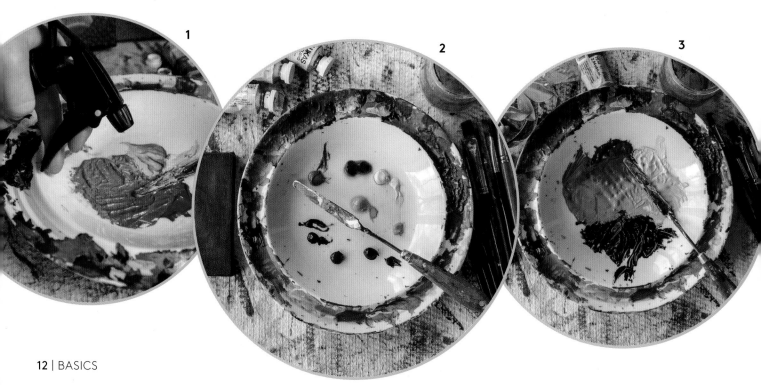

1

2

3

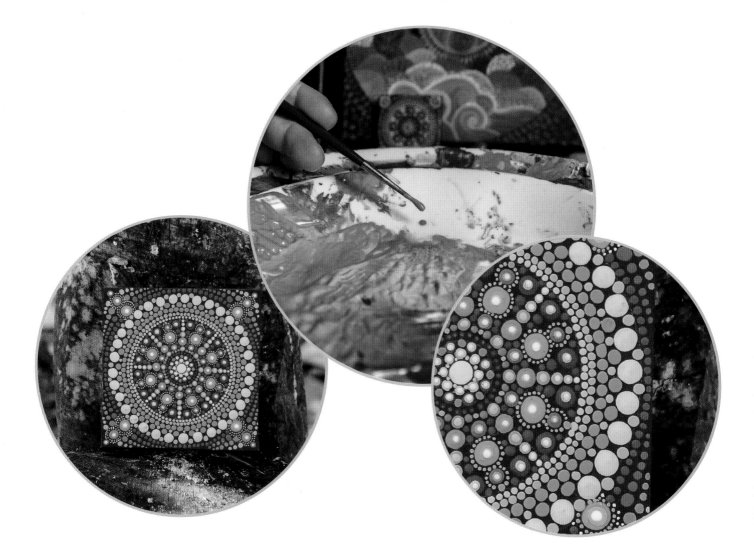

DOT-PAINTING TECHNIQUE

Two things are important for dot painting to succeed: a calm hand and the consistency of the paint. Small and extra small round brushes are the best choice for this. You'll know you have the right consistency when the paint doesn't drip off your brush, but rather is so smooth that it flows slowly. If you hold the loaded brush with the head facing down and allow the paint to slowly follow gravity, a gentle touch of the canvas is all that is required for you to leave the perfect dot. There is virtually no pressure from the brush required. Allow the paint to find its own way onto the canvas. If it is too runny, the dot will run; if it is too thick, it will be difficult to make the dot. I keep experimenting on the mixing plate until it works perfectly. For this technique, have the canvas flat on a surface so the dots are nice and even. And remember: practice makes perfect!

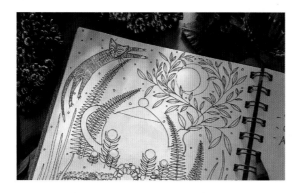

SKETCHBOOK

I like to have paperback sketchbooks with me so I can record fleeting ideas whenever they come to me. I put down everything that strikes me as relevant, without a filter. Mostly, it's things like plant patterns or textures that I happen to see and find exciting. This allows me to see what things look good together, and I can also refer back to them when I'm looking for ideas for a new composition or need a bit of a creative boost. What I like most of all is that nothing has to be perfect and I can just scribble anything and everything down without pressure and without letting my inner critic get too loud.

LABYRINTH

There are several different versions of the labyrinth symbol. One of the most famous labyrinths is set into the flagstones of the 13th-century cathedral of Chartres in France. It consists of twelve circles, but my version here is a simplified one with six.

1 Draw a total of six circles, each one bigger than the previous one, all with the same centre and evenly distanced from each other. The innermost circle is the centre. The size you make them depends on whether you are going to paint something in them later on. As far as the construction is concerned, the size doesn't really matter.

2 Draw the vertical and horizontal centre axes (for guidance only). The bottom entrance to the centre is exactly on the centre axis and is as wide as the distance between the circles. The left line connects the innermost circle to the outermost one, and the right line connects the innermost circle to the second circle from the outside.

3 Now draw the entrance to the labyrinth. This is on the left next to the bottom path to the centre, and of the same width. Connect a vertical line from circle 1 (outer circle) to circle 5. Now rub out the lines to make the entrance. Draw two more connecting lines above the centre, directly on the vertical centre axis: from the centre line to circle 4, and from circle 3 to circle 1 (outer circle).

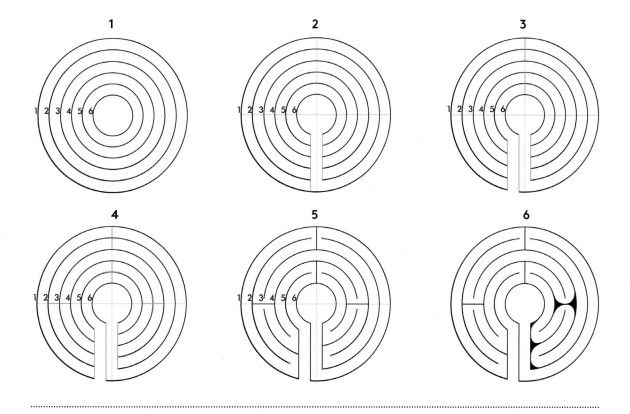

4 Now add the connecting lines on the horizontal centre axis. Draw a line from circle 2 to circle 4 on the left, and from circle 3 to circle 5 on the right. Add the curve points to the horizontal and vertical connecting lines. Mark them on the circle line between them, i.e. at the top and bottom or to the right and left of the connecting line. The curve points are at the same distances as the circles are from each other. There are two further curve points on circles 3 and 5 to the right of the centre path, and two on circles 2 and 4 to the left of it.

5 You now have the basic frame for the labyrinth. Rub out the areas of the circle lines between the curve points and the connecting lines. The path and its curves will now be a lot clearer.

6 You can highlight the curves graphically by rounding them off, or leave the route angular – whichever you prefer.

TRISKELION

Triskelion is the Greek word for "three-legged".
A triskelion consists of three radially symmetrical
circles, knots, spirals, triangles or other shapes.
Here, I'll describe the basic construction that
is common to them all.

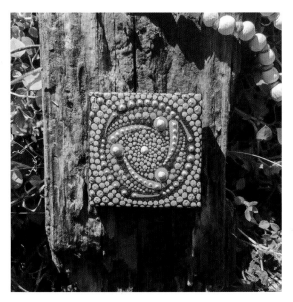

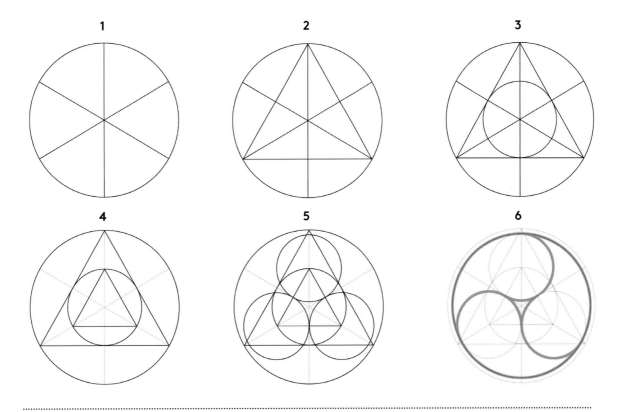

1 Draw a circle and use a compass or template to divide it into six equal parts.

2 Connect three of the corner points to make an equilateral triangle.

3 Draw a circle within the triangle with the circle lines and the boundary lines of the triangle exactly touching.

4 Draw another equilateral triangle within this circle with the corner points exactly on the circle line and on the same line as the corner points of the larger triangle.

5 The corner points of the smaller triangle form the centre points of the three circles that you will now draw. The radius is half a side's length of the smaller triangle.

6 Draw a large circle from the main centre point around the three newer circles with the circle lines on top of each other. You now have the basic shape of a triskelion, and can start to be creative.

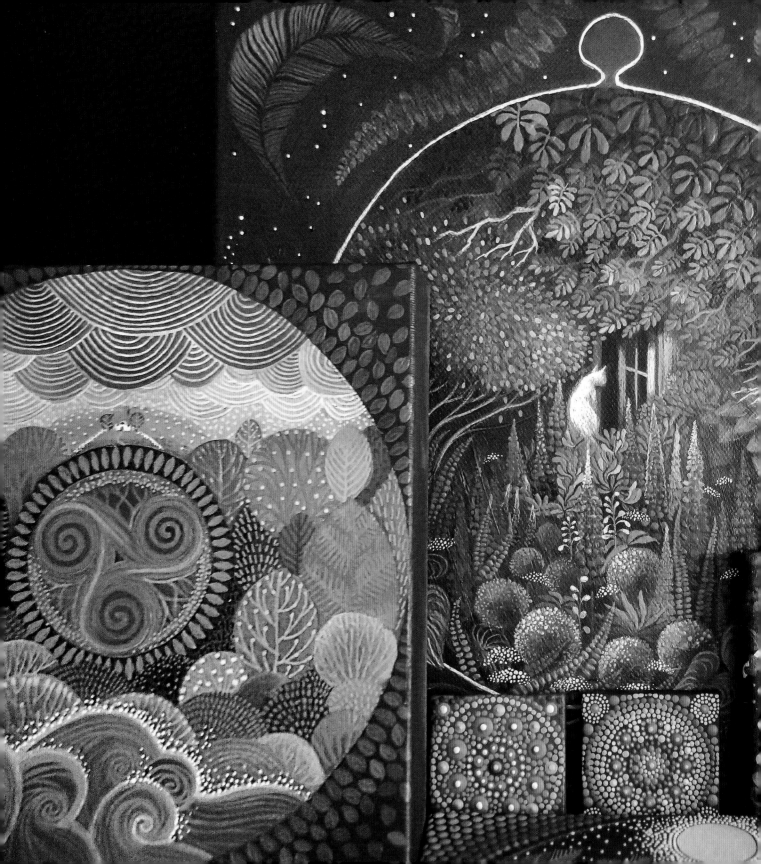

PROJECTS

MINI

Mandala

»SMALL IS BEAUTIFUL«

We'll start our exploration of the world of painting mandalas and dot painting with a mini mandala that combines the main techniques and principles. Mini mandalas are particularly charming because they are like little treasures; the smaller the filigree dot painting is, the more precious it is. If you're not sure about the size at first, or if your eyes perhaps aren't as good as they were, choose a slightly larger size that is right for you. Let's go!

Materials

Canvas: 5 x 5cm (2 x 2in)

Brushes: Acrylic brushes made of synthetic fibres; smaller flat brush for the base coat; very small round brush for the lines and the dot painting

Acrylic paints: Dark green for the base coat; warm and cool shades of green, copper

Other: Preliminary sketch with a white pencil and circular template

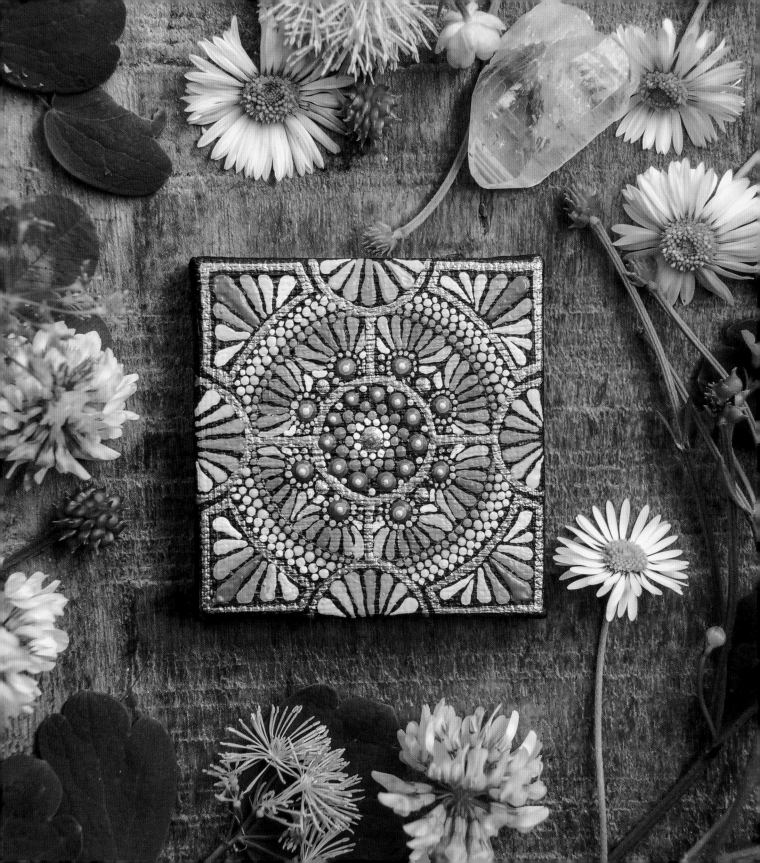

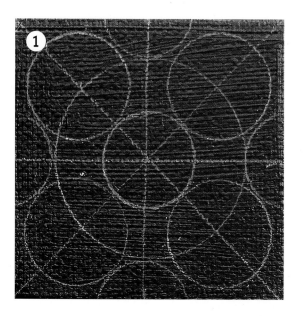

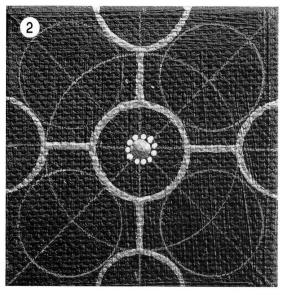

STEP 1

Cover the canvas in dark green. Once it is dry, use a light pencil to mark the centre of the canvas by drawing the diagonal axes and the horizontal and vertical symmetrical axes. Now draw a small circle around the centre point and semicircles of the same size at the ends of the horizontal and vertical axes. Add two slightly larger circles on the diagonal axes between the semicircles. Draw a large circle in the middle touching the outer edge of the semicircles.

STEP 2

Paint thin lines over the semicircles, the small centre circle and the straight connecting lines in the copper paint. Also in copper, put a dot of around 5mm (⅛in) on the centre point. Once it is dry, add tiny white dots close together around the central dot. Try to place the dots as close together as possible without letting them run into each other.

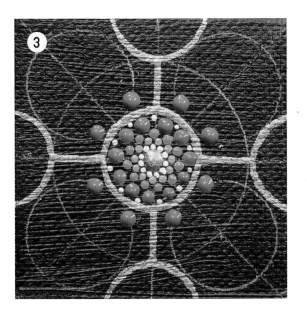

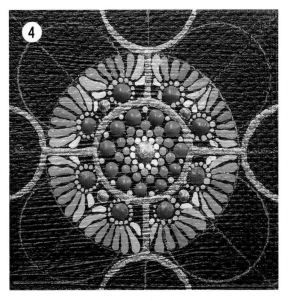

STEP 3

Using a light green, add a line of dots around the tiny white dots. Try to offset the dots from those in the previous row so they are positioned in the gap between two white dots. Make each row of dots a little bigger than the previous row. The challenge is to make the size and spacing of each row the same. Make each new row of dots a little darker than the previous row, so you end up with a colour gradient, and continue until you get to the copper line. Add eight larger dark green dots outside the copper circle.

STEP 4

Once they are dry, add little lighter coloured dots around them. Now fill in the spaces as far as the inner edge of the large circle with drop-shaped petals. Again, use various colours to create a colour gradient. I opted for a cool light green. Add four larger copper dots in the resulting gaps.

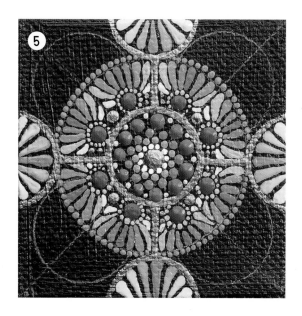 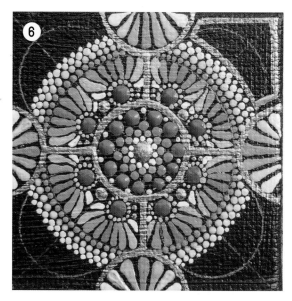

STEP 5

Use a warm light green to add little dots around the outer edge of the larger circle. Fill in the semicircles in various shades of the same colour, again in drop-shaped petals.

STEP 6

Add three more rows of dots to the outer circle in colours ranging from dark to light green. Now it's time for the corners. Paint thin copper lines around the shape of the corners.

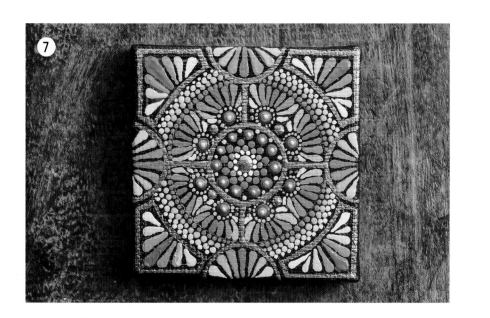

finished!

STEP 7

Again, fill the corners with drop-shaped petals. Choose a cool green, and start with the biggest drop in the middle. The drops should follow the shape of the corner, and become lighter towards the outside. You can now add some lighter-coloured touches to the thicker dots in the middle. This will create a pretty 3D effect.

CIRCLE
of Life

»LIFE IS CONSTANTLY CHANGING«

The triskelion reflects the magical number three, and is one of the oldest symbols known to us. It symbolizes themes such as past – present – future, birth – life – death and body – spirit – soul. Other interpretations consider the symbol as the sign of the triple goddess: maiden – mother – crone. It represents moving forward, like life, which never stands still. This painted triskelion mandala will remind you that we are all part of the vast circle of life.

Materials

Canvas: 12 x 12cm (5 x 5in)

Brushes: Acrylic brushes made of synthetic fibres; medium-sized flat brush for the base coat; small round brush for the longer dots; very small brush for the delicate lines

Acrylic paints: An earthy colour palette with light ochre, dark ochre, Sienna, Indian yellow; mauve for the base coat; gold for accents

Other: Preliminary sketch with a white pencil and circular template

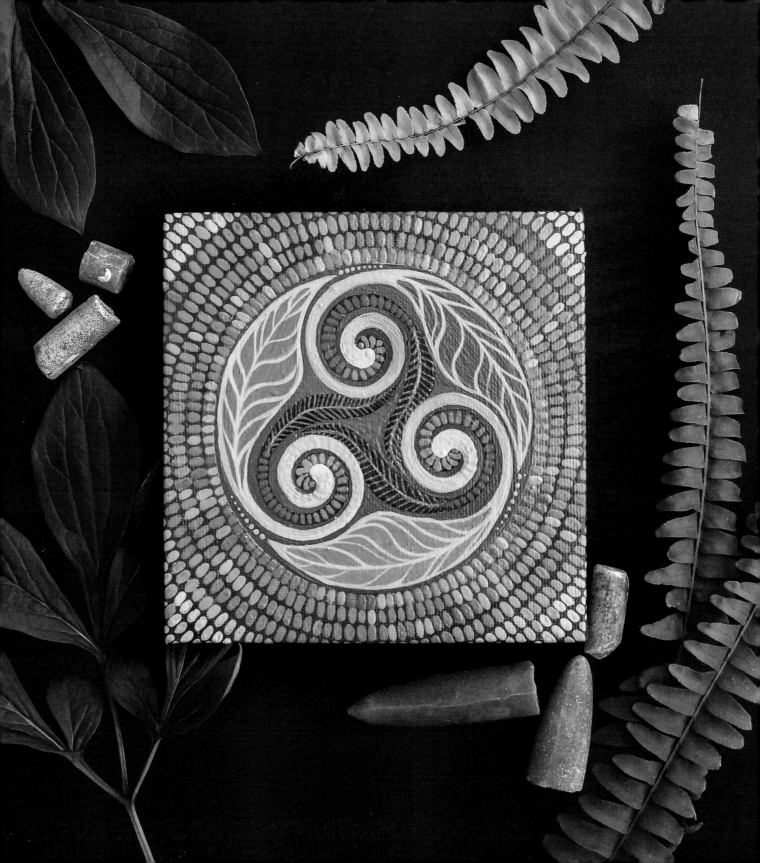

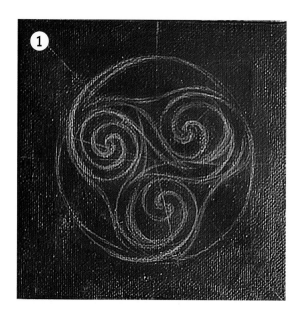

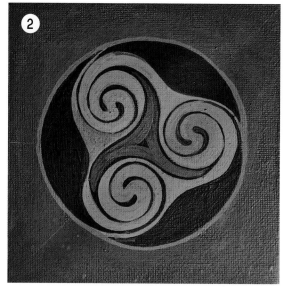

STEP 1

Start by covering the canvas in a dark opaque colour. I combined olive and indigo here to make a dark green. Mark the centre of your canvas and create the triskelion (see Techniques). It's a good idea to use a white or other light-coloured pencil that shows up well against the dark background.

STEP 2

I then drew a coloured sketch to check that the shapes worked well for me. I wasn't bothered about the final colours yet, so I simply used what was left on the palette for now. For this triskelion I combined two leaf shapes with the stalks wrapped around each other in a spiral. The centre of this spiral is the centre of the three circles from the sketch of the triskelion. Three long, narrow leaves meet at the centre. The outer shape of the triskelion is formed by three large abstract leaves that follow the rounded shape of the symbol.

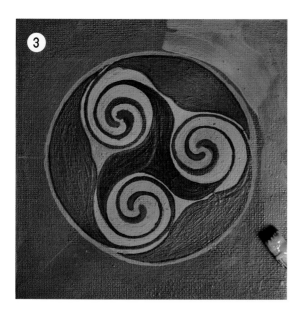 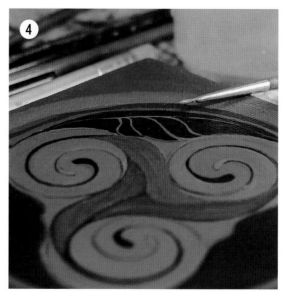

STEP 3

In this step, choose the colours for the two leaves. I chose a deep rust for the longer centre leaves. The outer leaves or areas are in a rich olive green.

STEP 4

Now take an extra thin round brush and light ochre, and paint the finely structured veins of the leaves. Try to use even, flowing strokes to create a decorative pattern.

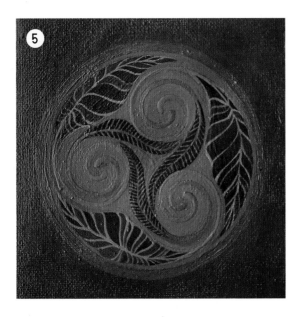

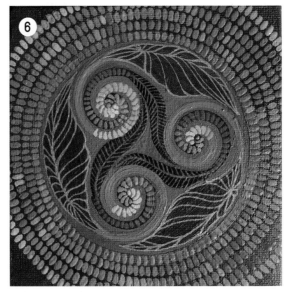

STEP 5

Next, paint the area outside the circle the same colour as the narrow leaves. Use a dark turquoise for the inside of the triskelion.

STEP 6

Dot painting is used for the last step, but here I opted for elongated dots arranged around the triskelion circle in several equally shaped rows. Try to place them as close together as possible without them running into each other. Alternate randomly between lighter shades of yellow and orange and dark shades of red and ochre so the end result looks organic and earthy.

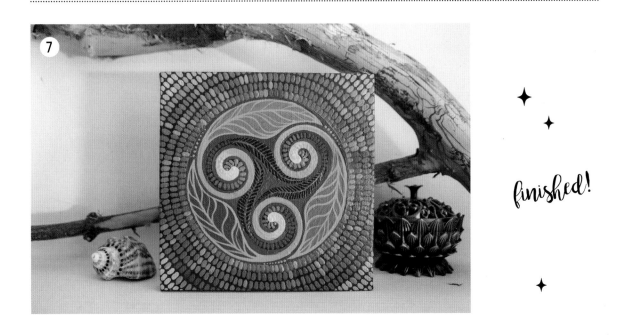

7

finished!

STEP 7

I also added the elongated dots to the leaf stalks, but when I looked at the mandala from a distance, I thought they were too much. Sometimes you can miss the point at which enough is enough. So I decided to highlight the three stalks of the outer leaves in a clear, bright yellow instead. This really makes the most of the spirals.

AUTUMN

Forest

»EACH END IS A NEW BEGINNING«

Nature bids us farewell with fabulous colours in autumn, then settles down to gain new strength through the winter. The trees seem to celebrate their farewell in every colour under the sun, like a fabulous festival. Here, the triskelion represents creation – preservation – destruction. This picture, with its highly colourful tree tops, is an homage to the circle of life in nature – and a reminder that every ending also contains a grain of renewal and growth.

Materials

Canvas: 20 x 20cm (8 x 8in)

Brushes: Acrylic brushes made of synthetic fibres; medium to large flat brushes for the base coat; round brushes in various sizes for the detail work

Acrylic paints: Autumn colours of green meet shades from red to violet; turquoise and yellow accents extend the colour range

Other: Coloured pencils for the sketch

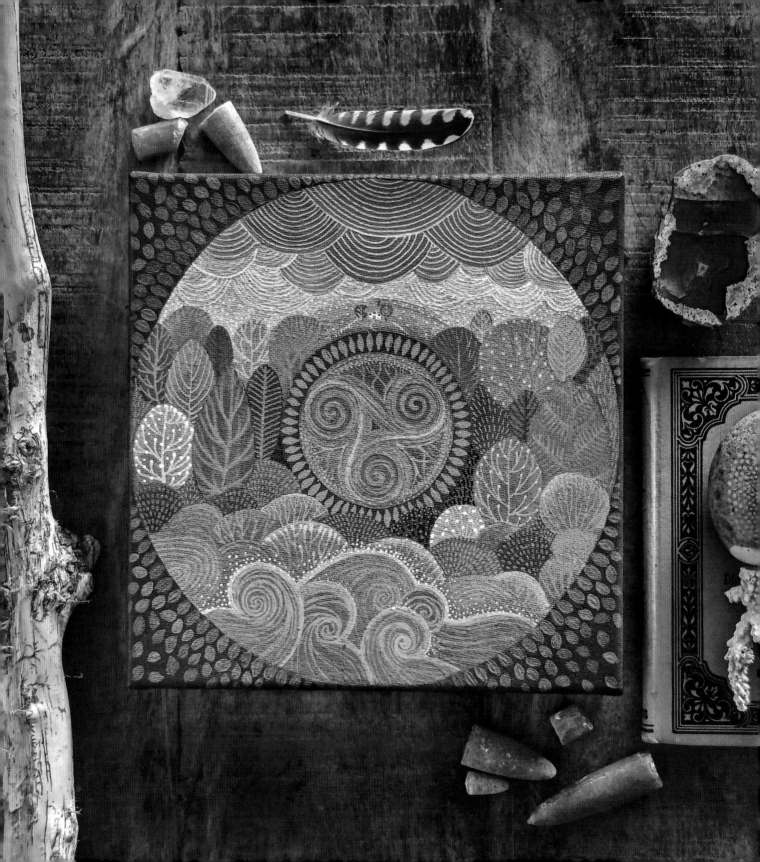

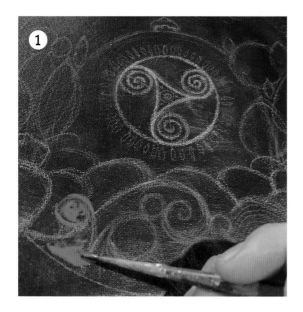

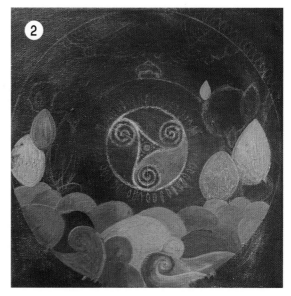

STEP 1

Start by covering the canvas in a combination of olive and dark green. Once it is dry, find the centre of the canvas and then use coloured pencils to sketch the arrangement of the tree shapes around the triskelion (see Techniques). In this version, I ended the three "feet" in a spiral. Next, we'll move on to the colour blocking.

STEP 2

Colour blocking means that rough areas of colour are used to find and test colour combinations to achieve the desired colour composition. Bushes and trees look like ovals and circles to begin with.

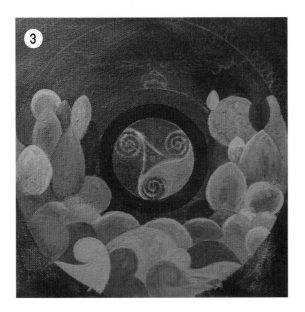

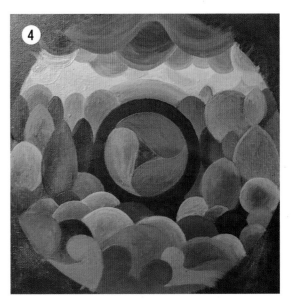

STEP 3

Start with the water at the bottom and work evenly up both sides. A medium-sized round brush is best for this. Continue working into the colour areas while they are still damp until you are happy with the colour combinations.

STEP 4

You can see the results of the colour blocking here. I've included the triskelion in the colours too. You can also gently shade the individual colour areas so the arrangement starts to look more lively.

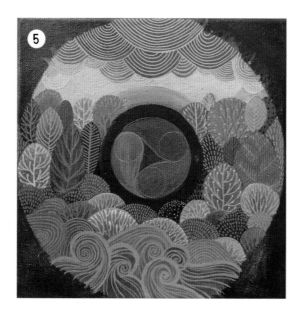 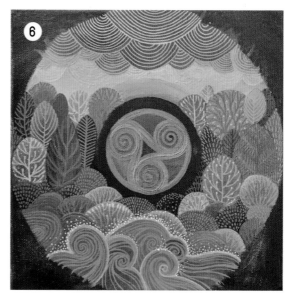

STEP 5

Now we come to my favourite part. Using a very fine round brush, paint fine lines and dots in the trees and brushes to represents branches and twigs. You have so much choice here! Add the wavy lines to the water and clouds. Stay within the same colour family for each so it doesn't become too much.

STEP 6

Now add the finishing touches to the triskelion in a warm ochre and olive green. This will make it look a little like wood so it blends well with the overall theme. Use dot painting (see Techniques) for the sea spray. Lots of tiny pastel blue dots will make the waves look dynamic and lively.

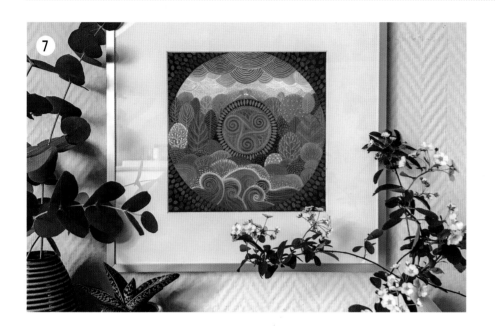

finished!

STEP 7

Now add lots of tiny leaves in dark green to the edges. Start on the circle line, placing them close together and working evenly. Allow them to become looser and more irregular towards the tip of the corner. Add a little edge of leaves to the triskelion as well, and fill the gaps on the spirals with delicate leaf patterns.

Tip

A walk in the countryside is a lovely way to stimulate your creativity. Find a few leaves or anything else nature bestows on you, depending on the season, and use them to decorate your work area. This will give you your own source of inspiration, courtesy of nature.

NATURE'S Treasures

»A GLIMPSE INTO OTHER WORLDS«

Allow this picture to transport you to the world of fungi, herbs and wild fruits. Herbalism has its roots in this world, and it was the birthplace of many myths and fables about all sorts of fabulous creatures. With this little picture of magical mushrooms, clover, ivy and jewel-like wild berries, I'd like to invite you to give your cognitive spirit a break and dream yourself deep into these spheres.

Materials

Canvas: 12 x 12cm (5 x 5in)

Brushes: Acrylic brushes made of synthetic fibres; medium-sized large flat brush for the base coat; round brushes in various sizes for the detail work; fine round brush for the dot painting

Acrylic paints: Cool and warm shades of green (sap green, chromium oxide green, olive green); light ochre, brown (burnt umber); white, orange and red for the accents

Other: White pencil for the sketch

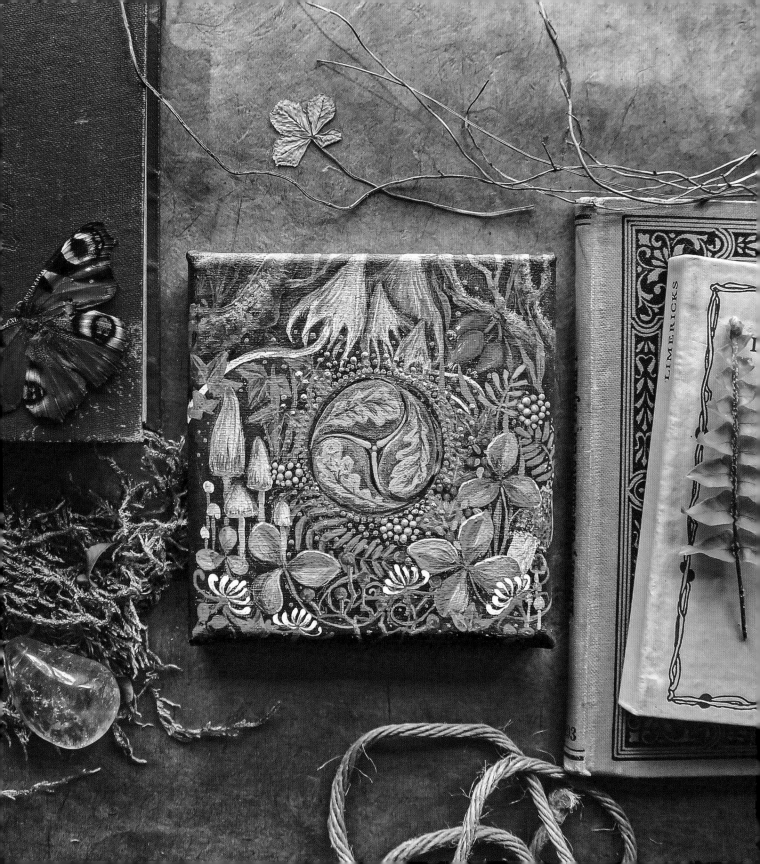

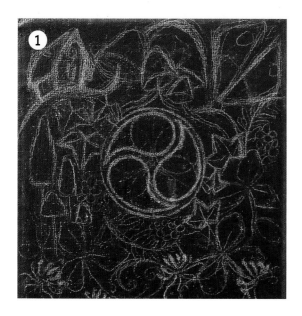

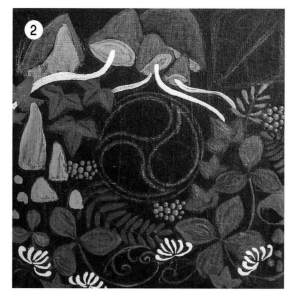

STEP 1

Start by covering the entire canvas in dark green. Use a white pencil to sketch the composition on the canvas when it is dry. Construct the triskelion in the middle of the canvas (see Techniques), using the white pencil. Arrange the clover leaves and flowers, ivy leaves and mushrooms in various shapes and sizes, in groups and individually around the triskelion. Be sure the arrangement is nice and dense, and that large and small shapes alternate – it shouldn't look too uniform.

STEP 2

Now paint the elements in appropriate colours. Using basic colours, fill the shapes first without paying too much attention to shading and texture. This will help you to see the underlying colour composition and to judge the balance between light and dark better. It also allows you to check that the colours work together.

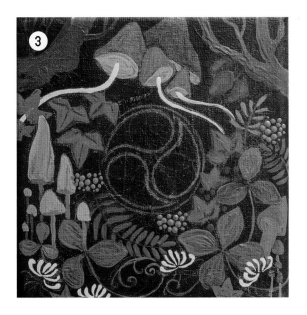 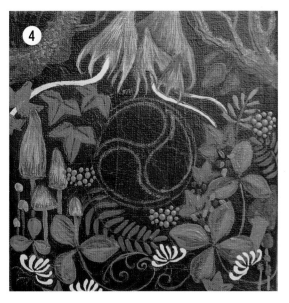

STEP 3

In this example, I painted over the little house that I had originally planned to put in the top left corner. It was too dominant in the composition, and I replaced it with some tree structures. For me, one very important point in painting is always to listen to what my instinct, or gut feeling, is telling me and to follow it. Now add the red elements and check that the colour works with the rest of the painting. If the colour composition looks harmonious, you can start to develop the various elements.

STEP 4

Next, you'll need a little patience and practice. Using the basic colours that you probably still have on the palette, mix a few light and dark shades. This may take some time, but it's good preparation and you'll be able to work quickly afterwards. Start to define the veins of the leaves and the halves of each clover leaf, using a fine round brush.

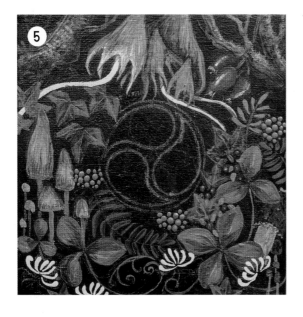

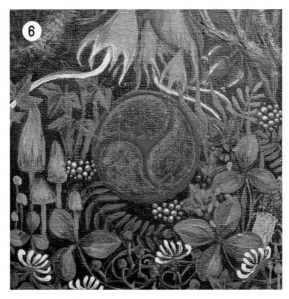

STEP 5

Next, do the same with the mushrooms as you did for the leaves; use shades of ochre and brown to shape the mushroom caps. Add fine lines to create texture and, if necessary, adjust the shapes. Using a thin brush, carefully add shades of yellow and green to the trees so they look like a layer of moss. Add a few light dots to the berries as accents to make them shine.

STEP 6

Now it's time to work on the triskelion. I decided to make it illustrative rather than abstract, and added a dark green mossy texture to the three inside areas. Do this in the same way as you applied the layer of moss to the trees. Paint the outer lines in a grey-brown that matches that of the mushrooms. A few more berries in blue and a wine red add more colour accents and complete the composition.

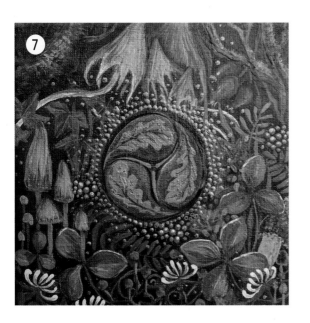

finished!

STEP 7

Finally, paint oak leaves on the mossy texture of the inner parts of the triskelion. They fit in well with the theme of the picture. Use the dot painting technique (see Techniques) to work copper-coloured dots around the outer edge of the triskelion. They will "float" to the outside in every part of the picture. Add a few light lines in ochre and copper to accentuate the triskelion.

SILENT
Night

»LISTEN TO THE SILENCE AND FIND YOURSELF«

The deep shades of blue of this picture will take you into the silence of the night, where your thoughts can move away from the noise and bustle of everyday life. They will transport you out into the magic of a moonlit forest. Dream yourself into a haven of warmth and comfort, and listen to the sighing and rustling of the trees. Feel how your entire being gradually relaxes into a state of calm and peace.

Materials

Canvas: 12 x 12cm (5 x 5in)

Brushes: Acrylic brushes made of synthetic fibres; small flat brush for the base coat; small and extra small round brushes for the detail work

Acrylic paints: Cool shades of blue and green that blend with the dark blue of the night; light accents that define the branches, smoke and house

Other: Preliminary pencil sketch on paper

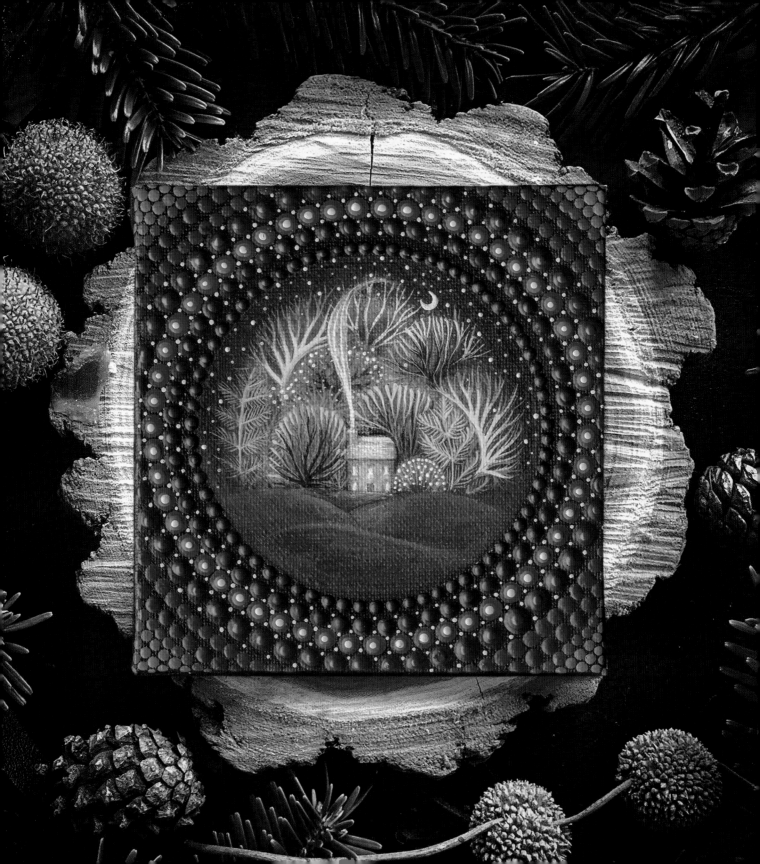

Let's get started

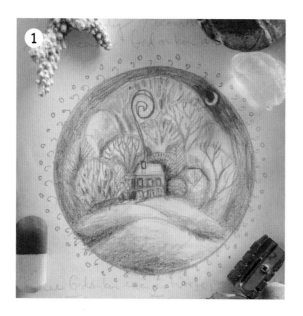

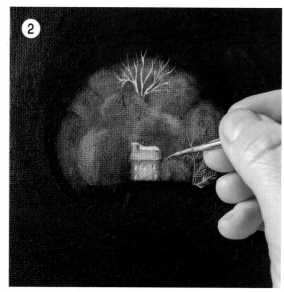

STEP 1

First of all, draw an initial design in pencil on a piece of paper. A black-and-white drawing has the advantage that you can decide in advance where to put the light and dark areas in the picture before you add the colour. This will allow you to see whether the composition works and the overall effect of the picture.

STEP 2

Once you have covered the canvas in a very dark indigo blue, draw a circle in pencil in the middle, leaving a bit of space as a border. Transfer the sketch you've already created into the circle as a colour design. Take a slightly lighter blue and roughly divide the trees into light and dark areas. Add more detail to the house at the same time. Use an extra fine round brush because the format is very small – and therein lies its charm.

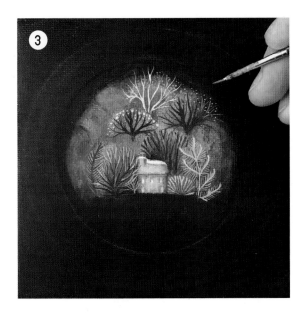

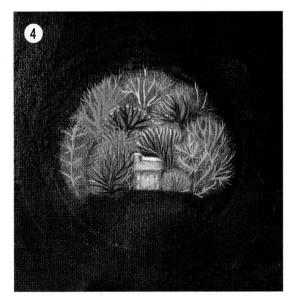

STEP 3

The colour palette keeps to dark, cool night colours with the sole exception of the warm yellow glow from the windows. This creates a pretty contrast. Use dark blue to hint at the tree trunks, and add fine branches and highlights to the top of the trees in light pastel blues and greens to indicate the light of the moon.

STEP 4

Painting a pretty and varied line style for the twigs and branches allows you to create a lively and interesting composition. The house, in contrast, is at peace in the middle, where the observer's eye can linger. For the next step, return to the circle line that you drew at the beginning.

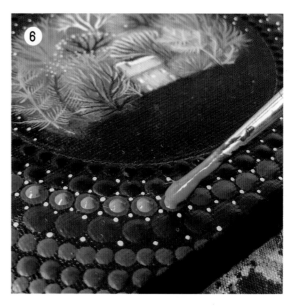

STEP 5

You can see how I created the dot pattern here, though you can create your own version. To make sure the dot painting works for you, go back to Techniques and read how to paint perfect dots. Start the first row with a dark blue directly on the circle line. The remaining rows build from this first one. This is why you need to make sure that the distances between and the size of the dots are all the same. For the second row, put the dots in the gaps between the dots of the first row. Make the dots in each successive row a little bigger. Make the dots in the corners a little lighter towards the outside to create a colour gradient.

STEP 6

Once the first layer is dry, you can build up the dots by highlighting them. Choose a row and mix a lighter blue. Now add a smaller lighter drop to each dot. Warning: this is definitely addictive! I usually find it very difficult to stop – it's like a kind of painting meditation.

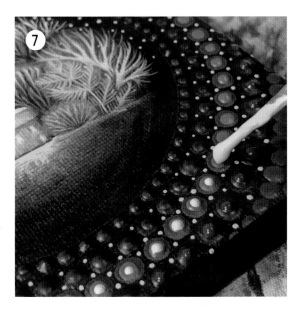

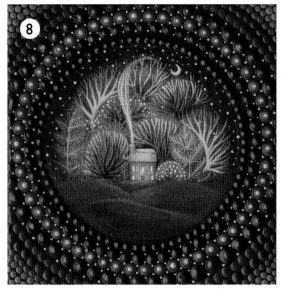

STEP 7

Once this layer is dry, use a white with a slight touch of blue and add a final tiny highlight to each dot. This will make the dots "pop" and create a 3D effect.

STEP 8

To finish, add a few gentle contours to the meadow in front of the house, followed by the moon, the stars and the smoke from the chimney.

BLOOMING

Midsummer

»ENJOY THE ABUNDANCE AND BEAUTY OF NATURE«

Nature reaches her peak around the time of the summer
solstice. Everything is in full bloom, and can be enjoyed using
every one of our senses. It's a time that is full of magic and
mystery. Plants are said to have healing powers, and wearing
a wreath of flowers in your hair at the time of the summer
solstice is an ancient symbol of rebirth and fertility. This little
flower mandala is a reminder of this beautiful tradition – and a
reminder to enjoy the fabulous flowers of summer to the full.

Materials

Canvas: 7.5 x 7.5cm (3 x 3in)

Brushes: Acrylic brushes made of synthetic
fibres; medium-sized flat brush for the base
coat; extra small round brush for the details

Acrylic paints: A soft turquoise for the base
coat; warm and cool shades of green; white
and yellow for the flowers and highlights

Other: Preliminary sketch with a white pencil
and circular template

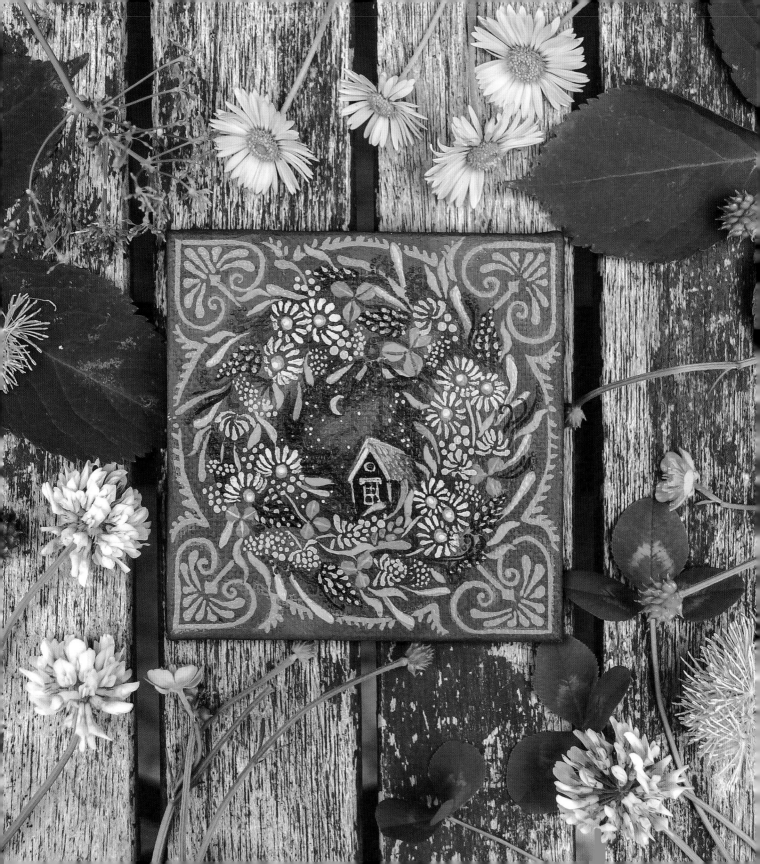

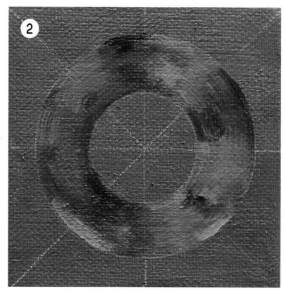

STEP 1

Start by covering the canvas in turquoise. It shouldn't be too strong. When the paint has dried, mark the centre of the canvas and draw the diagonal, horizontal and vertical symmetry axes. Use a white or other light-coloured pencil that shows up well against the dark background. Draw two circles about 3cm (1in) apart with the same pencil.

STEP 2

Now paint the space between the two circles in different shades of green. Make sure there are a few light and dark areas that contrast well with each other. I used a smaller flat brush because it doesn't have to be too precise.

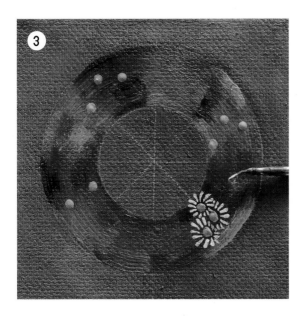

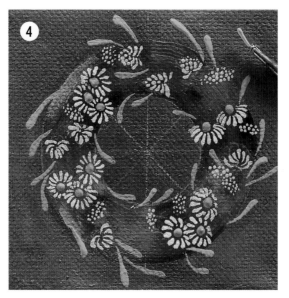

STEP 3

Once this coat is dry, you can start on the flowers. Loosely paint a few dots of yellow, then add the white daisy petals around them with an extra fine round brush. Try to place them primarily on the green circle.

STEP 4

Take an extra thin round brush and paint some more dotted flowers in soft shades of pink and yellow. Then place some small, long leaves in a shade of sage so they protrude over the sides. Take care to place them all in the same direction.

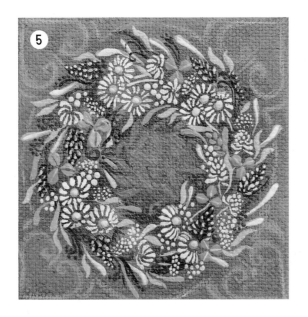

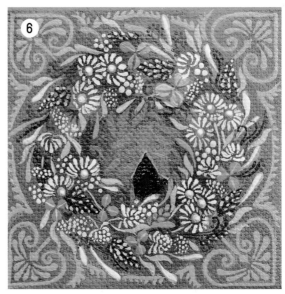

STEP 5

Finish the wreath with clover leaves and small accents in wine red. The wreath should be evenly covered but not overloaded. Of course, you are free to choose any flower and leaf shapes you like. Use the white pencil to add a simple pattern to the corners.

STEP 6

I finished the pattern in the corners in a lighter shade of turquoise using a fine round brush. The idea is for it to be rather understated so that the focus remains on the wreath. Finish the picture with a little house at the heart of the wreath. Place it in the bottom corner so part of it is hidden from sight. Roughly paint the walls and the roof and wait for the paint to dry.

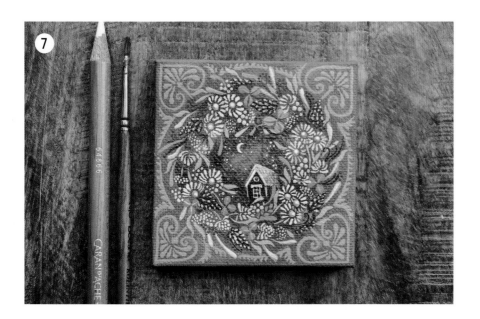

finished!

STEP 7

Finish by adding the details to the house in white using an extra fine round brush. If you like, you can add a little moon and some stars. I darkened the inner area a little before doing this so the stars would shine more brightly.

LOYAL

Companions

»THE CIRCLE OF LIFE«

Animals are our friends and loyal companions. They love and trust us unconditionally. This is what makes a relationship with an animal precious and unique. Often, it isn't until we have to say goodbye that we fully realise just how strong this connection is. While I was writing this book, I had to say goodbye to a much-loved cat. This picture of a magically glowing night and the triskelion in warm shades of gold and copper as the symbol of life – death – rebirth is an homage to her.

Materials

Canvas: 20 x 20cm (8 x 8in)

Brushes: Acrylic brushes made of synthetic fibres; medium-sized flat brush for the base coat; small round brushes for the detail work; fine round brush for the dot painting

Acrylic paints: Blue-green and yellow-green, plus earthy shades such as dark and light ochre; copper and gold for the highlights

Other: White pencil for the sketch

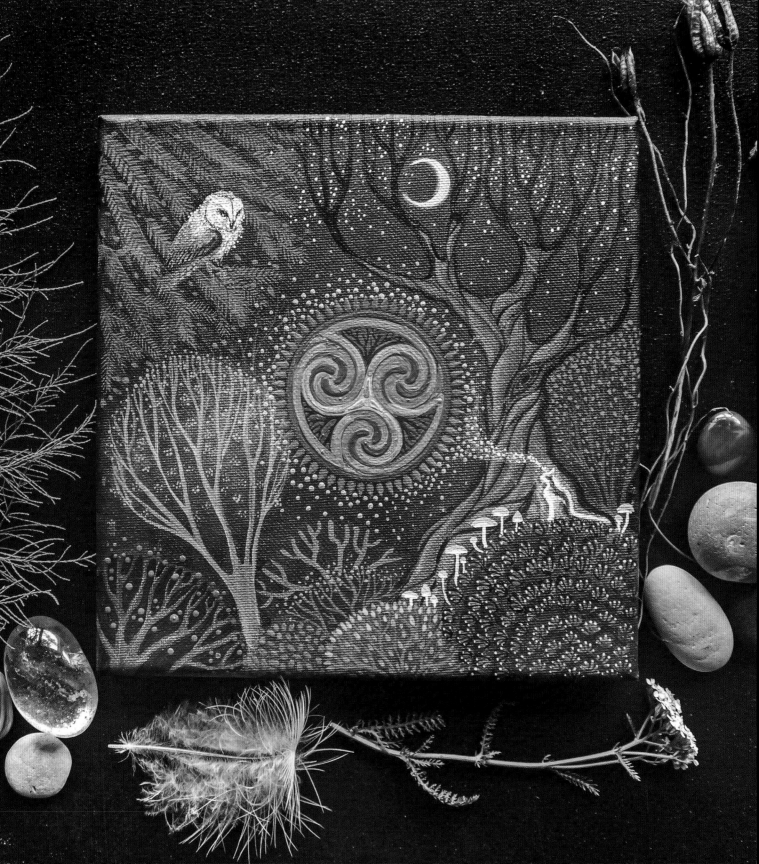

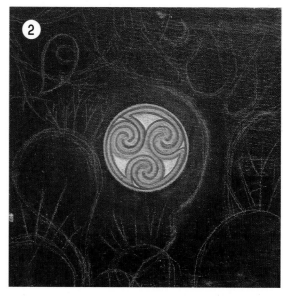

STEP 1

Start by covering the entire canvas in a mixture of indigo and dark green. Both the shades of green and the earthy hues develop a beautiful brilliance on a dark background later on. Once the first layer of paint has dried, create the triskelion (see Techniques). I've already done a rough sketch of the tree on the right as an aid to composition. Paint the triskelion in strong shades of orange and yellow.

STEP 2

When the paint is dry, draw the rest of the composition on the canvas in a white pencil.

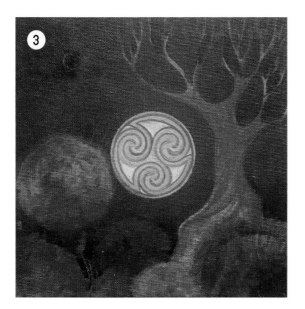 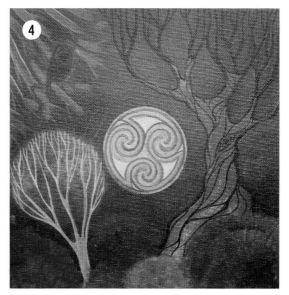

STEP 3

Paint roughly over the composition in shades of green and brown, applied with a medium-sized flat brush. This step is mainly about creating the shapes and making sure the composition is right. It's important to achieve a balance between large and small shapes and how you arrange them. Look, and follow your instinct.

STEP 4

In the top left corner, I imagined pine branches hanging over the picture with an owl on them. Roughly paint the branches in a blueish green with a flat brush. Use a finer round brush and some dark brown to paint thin rounded lines on the tree on the right that follow the rugged lines of the wood. I used a light ochre and a fine round brush for the branches of the tree on the left.

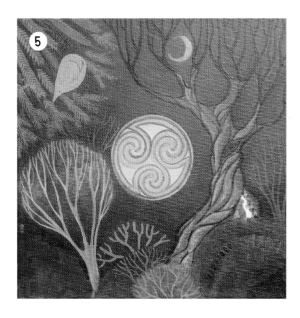 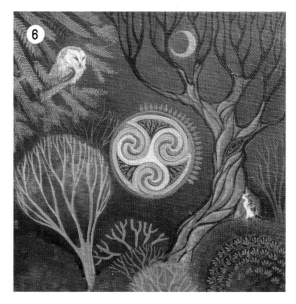

STEP 5

Now it's time to move on to the more detailed work. Use various shades to paint the leaves and branches of the bushes and add some trees in the background. Find your own way of stylising them, and stay with it. This will result in a lovely texture with your own characteristic style. Now you can roughly add the owl, moon and cat.

STEP 6

You have now established the colour palette of the picture and can paint the triskelion to match. Earthy shades of brown, green and ochre correspond with the other elements in the picture, so the triskelion will blend harmoniously. Again, you can add some small branch elements. A wreath of stylised leaves will create a bridge between the symbol and the landscape.

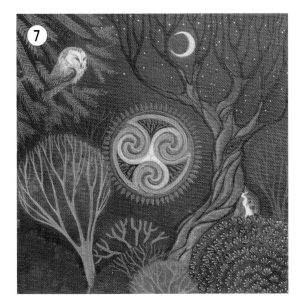

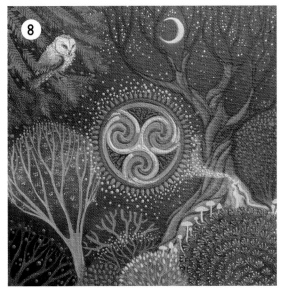

STEP 7

Now it's time to move on to the owl. Using a fine round brush, indicate the wings and feathers. Again, be sure to remain within the colour palette so everything integrates well in the composition. It is also important to retain your style, and not get lost in working out the details. Sometimes it's more effective – and more charming – to hint at something rather than create a complete representation. It is often more exciting to allow the eye to add any missing details.

STEP 8

Now make the picture glow by using dot painting to place stars and golden dots around the triskelion. The cat is also given a bright shimmer. Use a small flat brush misted with a mixture of white and gold for this; it should be almost dry. Then brush lightly around the outline of the cat until the desired shimmer becomes visible. A stream of golden and white dots connects the cat to the symbol. Add the last colour accents to the bushes and a few mushrooms to give the picture its final enchanting touches.

SECRET
Garden

»LET THE MOMENT BECOME ETERNITY«

Come into a garden full of flowers, where time seems to have
stood still. In the exhilaration of scents and colours, leave everyday
life behind you – and the moment stretches to become eternity.
You'll find unimagined windows are opened up into other worlds.

Materials

Canvas: 30 x 30cm (12 x 12in)

Brushes: Acrylic brushes made of synthetic
fibres; medium-sized flat brush for the base
coat; round brushes in various sizes for the
detail work

Acrylic paints: Green earth, olive, indigo for
the base coat; chromium green, light ochre,
olive green and Indian yellow for the leaves;
mauve, magenta and lilac for the flowers

Other: White pencil, compass or circular
template

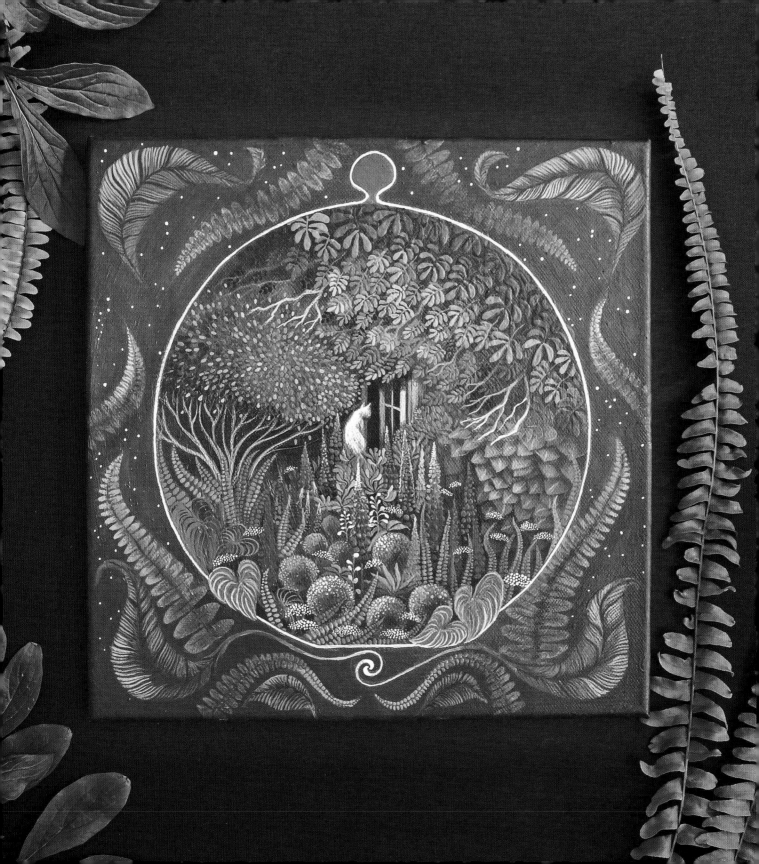

Let's get started

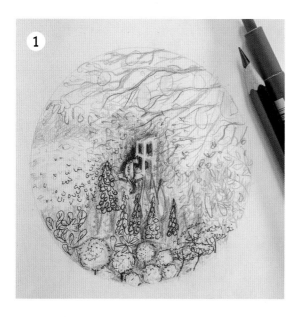

STEP 1

For this picture, I had a specific idea of a garden full of flowers, the house at the middle of it almost completely concealed; an open window, just visible between the leaves, the only indication of its existence. I captured the idea in a sketch using pencil and fine liner.

STEP 2

Cover the entire canvas in a mixture of dark green (Green earth) and indigo. Then quickly add the lighter areas of the composition using a large flat brush and a light olive green. When it has all dried, transfer the sketch in white pencil. Place it in a circle in the middle of the canvas, leaving a border.

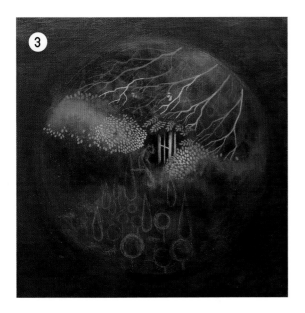

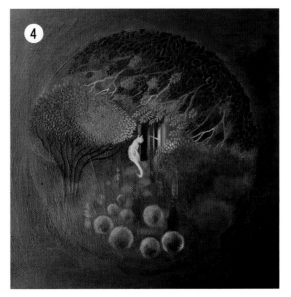

STEP 3

As the window represents the deepest level of the picture, paint that first in a light shade (not white), then continue working on the leaves, working from the window to the outside. Use lighter neutral shades of green that contrast well with the base coat. Capture the movement of the tree as you paint the branches and twigs.

STEP 4

Now paint the leaves along the branches, making them lighter nearer the window and getting darker to the outside. Do the same with the shrubbery to the right and left of the window. Use a mixture of lilac, mauve and magenta for the flowers at the front of the picture. Pay attention to the way the light falls, and paint lighter and darker areas accordingly, especially on the circular flowers. Although the cat looks white, never use a pure white but always add a little of the surrounding colours.

Let's continue

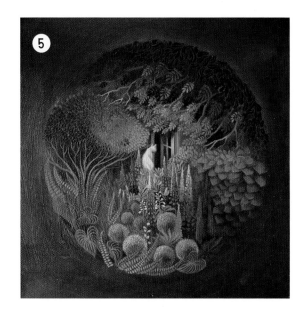 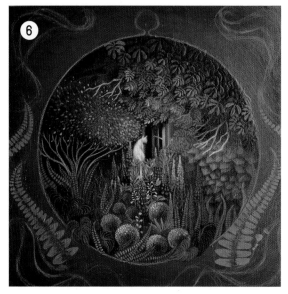

STEP 5

Now gradually work on the rest of the details. Add ferns, leaves and flowers. Keep checking by looking at the picture from a distance of up to two metres (6ft) to make sure that the shapes and colours still look harmonious, and nothing is overdone. Arrange the flowers so they draw the observer's eye to the centre and the cat. You can make the sides a little calmer.

STEP 6

When you are happy with what you have done so far, you can move on to the sides. Check that you have still got the circular shape, otherwise go over it again in the colour you used for the base. Paint the thin outline of a cloche in a gently muted white and using a thin round brush. I followed the circle line. Now transfer two of the leaf shapes from the picture to the edges in a pattern. Make sure that the leaves are symmetrical to the vertical axis. I used a grey-green shade of sage here.

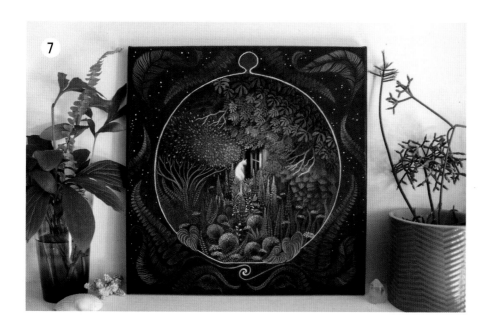

7

finished!

STEP 7

When you have finished arranging the leaves in a pattern, use a fine brush to add light accents to the leaf structures. Add little white dots as stars to complete the picture.

DREAMING

Wind Fish

»NEVER STOP DREAMING«

This picture is based on the mythical figure of the wind fish from the Japanese cult game "The Legend of Zelda". The wind fish is magnificently decorated in a combination of mandala and dot painting. The waves are in the style of the Japanese artist Hokusai as a reference to the cultural background. The wind fish, who is able to create worlds while dreaming, considers the observers with wise eyes.

Material

Canvas: 40 x 40cm (16 x 16in)

Brushes: Acrylic brushes made of synthetic fibres; medium-sized flat brush for the base coat; round brushes in various sizes for the detail work

Acrylic paints: All the colours of the sea, from a deep blue to turquoise; shades from violet to bright pink for colourful contrasts; accents in a soft yellow

Other: Preliminary pencil sketch on paper

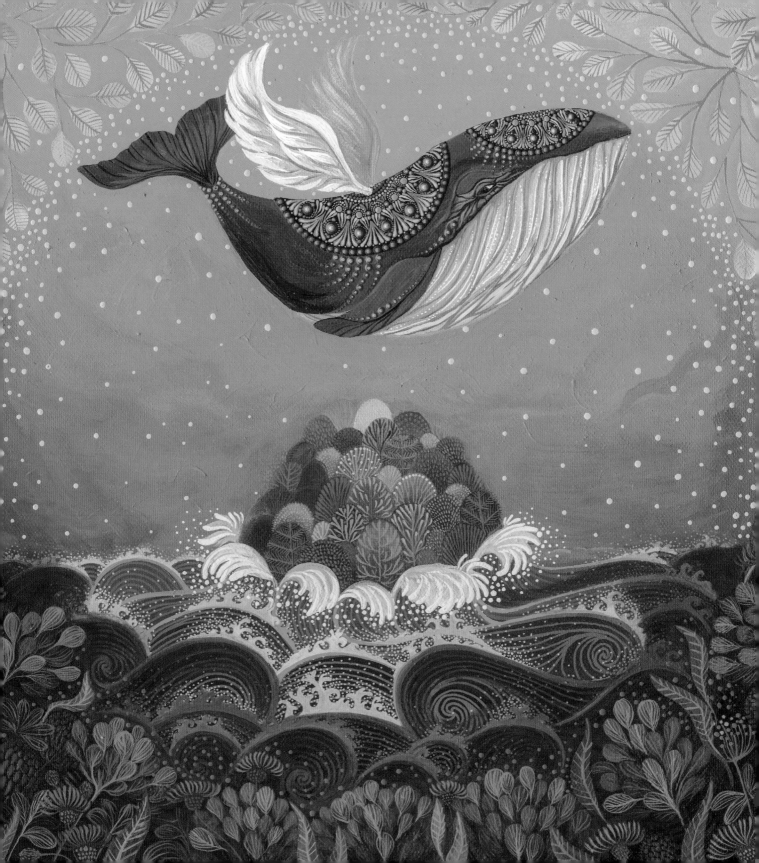

STEP 1

I use the preliminary sketch to decide on the composition, the size of the shapes relative to each other, and which structure-giving plant elements go well together. The wind fish and the island are clearly the focal point of the picture. They are placed directly on the centre of the vertical axis. I arranged the plant structures along the sides in a circle around the motif so they underscore the symmetry.

STEP 2

First prepare the entire canvas using a large flat brush. In order to achieve a pretty gradation of colours, I put a few dots of indigo on the bottom edge, a few dots of ultramarine in the middle, and a few dots of turquoise in the top third. Quickly blend all these colours using horizontal brush strokes, making them long and even. If the paint is a little too thick, moisten the brush with a little more water. When you are satisfied with the colour gradient, leave it to dry thoroughly.

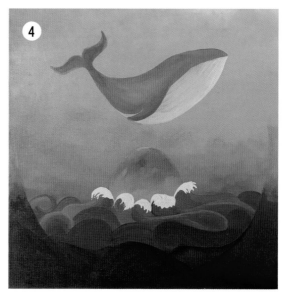

STEP 3

Determine where the vertical centre axis of the canvas is, and draw rough outlines of the island and the fish in the middle. You can already define the light belly of the wind fish.

STEP 4

Now make the circle formed by the plants around the motif. Cut out a circular paper template and draw around it with a light coloured pencil. Make sure you put it right in the centre. You can now also indicate the shapes of the waves.

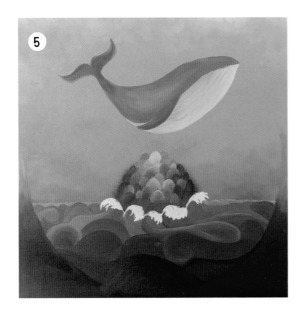

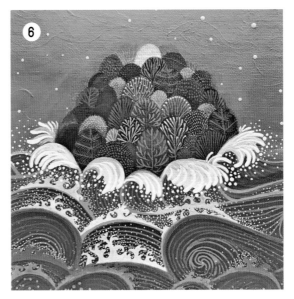

STEP 5

Now paint the island's treetops in shades of violet and bright pink, adding a few pale yellow accents here and there. Don't make the colours too rich yet, as you'll be adding more brightly coloured accents later. The palette should be reminiscent of a colourful autumn forest.

STEP 6

Use the same shades of each particular tree to add the accents to the treetops. Mix the colour to make it a little lighter and richer. Paint very fine lines over the branches, and do the same with the waves. Use dot painting (see Techniques) to paint the waves, and paint lots of dots.

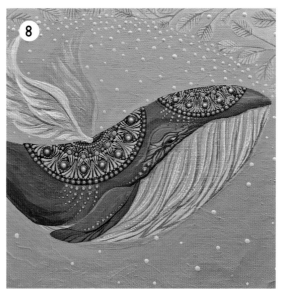

STEP 7

Next, work on the leaves and plants. Make sure that they are all leaning towards the centre of the canvas. The branches should be nicely balanced and the style consistent.

STEP 8

Use dot painting to decorate the wind fish. Use a template or compass to draw the semicircles on the fish's back so they are nice and even. Draw the main points first and check to see that they are equally spaced. You can add the droplet shapes and small dots around it later. There are absolutely no limits to the patterns you can make.

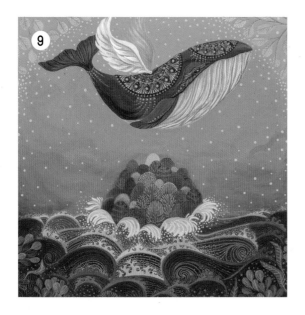

Tip

Have a look at the famous painting "The Great Wave off Kanagawa" by Katsushika Hokusai. It is regarded as the best-known piece of Japanese art in the world, and many artists have been inspired by it. Let it inspire you too, and find your own way of expressing the lines in this picture.

STEP 9

Check that all the transition points are nice and harmonious. Look at your work from a long way away. This will allow you to see where it may still be necessary to make some additions.

finished!

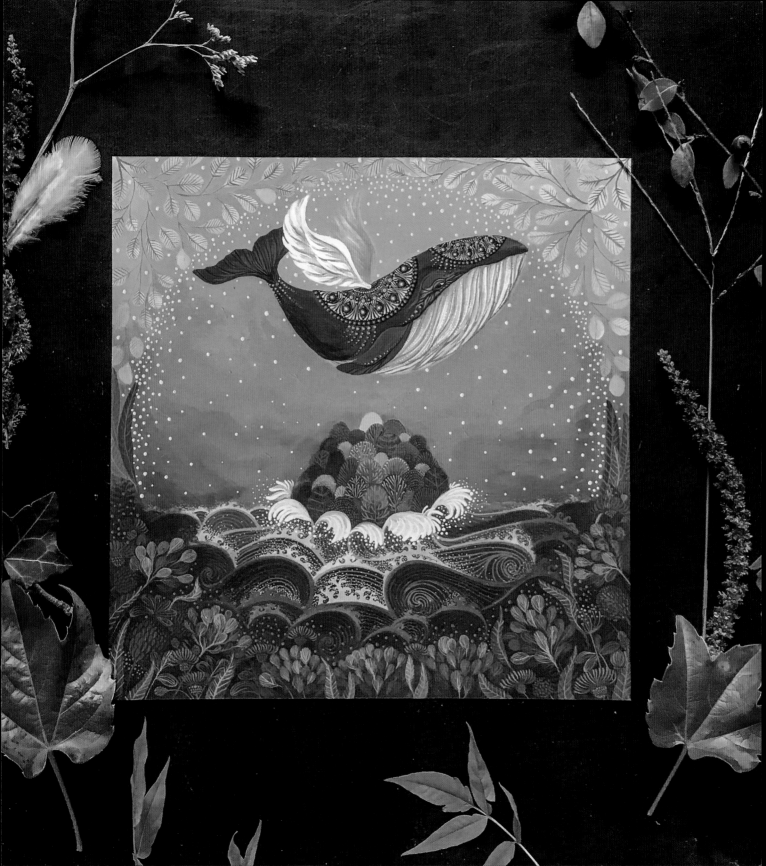

WATER LILY
Labyrinth

»DEVELOP YOUR POTENTIAL«

This picture invites you into the depths of the underwater world. The pure flowers of the water lilies seem to rise up from the dark depths and float towards the light. Boldly, they embark on their journey from the darkness of the muddy floor to stretch their flowers up towards the light so they can open. The stems wind weightlessly in gentle movements through shades ranging from dark green to turquoise. Dive down into the depths of your being.

Material

Canvas: 40 x 40cm (16 x 16in)

Brushes: Acrylic brushes made of synthetic fibres; medium-sized flat brush for the base coat; round brushes in various sizes for the detail work

Acrylic paints: Green earth with indigo; turquoise for the colour gradient; chromium green, light ochre, mauve for the leaves; pink and magenta for the flowers

Other: White pencil for sketching

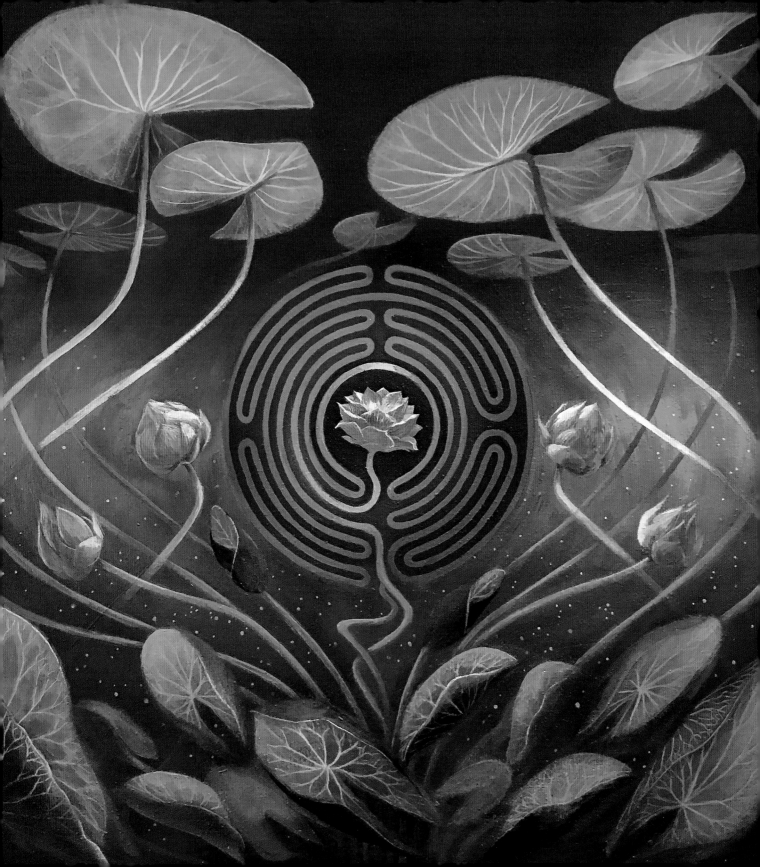

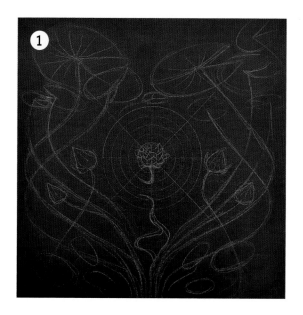

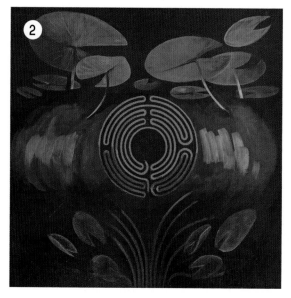

STEP 1

First cover the entire canvas in a mixture of dark green (Green earth) and indigo. Then take a white pencil and decide roughly on the composition. I used a circular template for the labyrinth. Sketch the sizes and positions of the water lily leaves. The stems wind left and right around the labyrinth symmetrically to the vertical axis. They are based on decorative elements used in Art Nouveau, so let yourself be inspired by works of art in this style.

STEP 2

Work a colour gradient in turquoise along the horizontal centre axis. Colour the leaves of the water lilies in light and dark shades of green. The leaves on the surface are much lighter than those deeper down because of the way the light falls on them. Paint the labyrinth (see Techniques) in a light green.

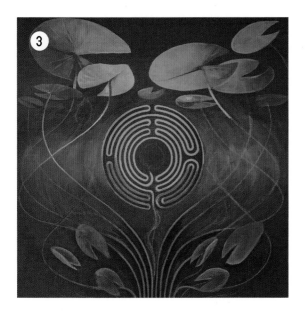

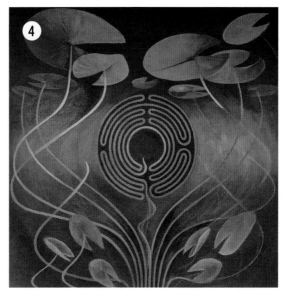

STEP 3

When the paint has dried, take the white pencil and draw in thin lines to indicate the exact positions of the stems. Paint over the lines in a soft pink with a thin round brush. Think about how you want the stems to cross over each other. There are absolutely no limits on your imagination with this pattern.

STEP 4

Working from the vertical centre axis, paint both sides of the labyrinth in a colour gradient that reflects the colours of the rest of the picture, starting with turquoise at the top, then from green to yellow to the bottom, ending in the pink of the stems. It's a good idea to mix the colours beforehand so you can work more quickly.

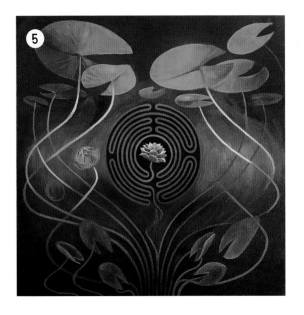

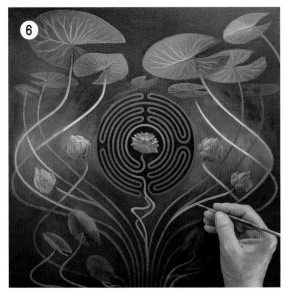

STEP 5

When you have finished the stems, place the flowers where you would like them to be. Roughly outline the shapes in pink, then add the details, such as the individual petals, using a very fine brush. Paint lighter and darker areas to simulate the way the light falls on the flowers, which will create the feeling of space.

STEP 6

Add the veins of the leaves in a lighter shade than the one used for the leaves. The colour is stronger in the places where the light falls from above, and almost invisible in darker areas. Highlight the stems at the front of the picture in a very light pink, while the ones further back should almost take on the colour of the dark background. This will create a mysterious depth to the picture.

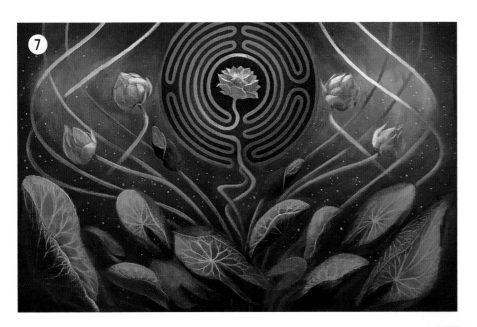

finished!

STEP 7

To finish, add some still unfurled petals to the water lilies at the bottom. Again, start with the rough outlines first and then continue as for step 6. Add tiny, light, floating dots as the finishing touches. Even if you're confident about your composition at the beginning, don't be afraid to deviate from it during the creative process. Listen to your instincts!

At the end, add fine, very light lines along the edges of the leaves and the stems as highlights, as if the light were falling on them from above. This will give you defined shapes and make them more 3D.

SPIRIT OF
Paradise

»CELEBRATE THE BEAUTY OF YOUR CREATION«

This picture is a celebration of the unique beauty and abundance of nature. The principle of the spiral is found in every area of creation: from DNA strands, snail shells and the spiral growth of the fern to entire galaxies. This observation tells me that everything is interconnected, and is governed by and follows universal principles. The copper-coloured spiral at the centre of the picture is elegant and precious, yet earthy at the same time. The bird-of-paradise flower complements it with its glorious colours and luxuriousness.

Materials

Canvas: 40 x 40cm (16 x 16in)

Brushes: Acrylic brushes made of synthetic fibres; round brushes in various sizes for the detail work

Acrylic paints: Palette ranging from the dark colour spectrum with shades of violet; greens and turquoises; copper and a strong yellow-orange add glowing accents

Other: White pencil for sketching

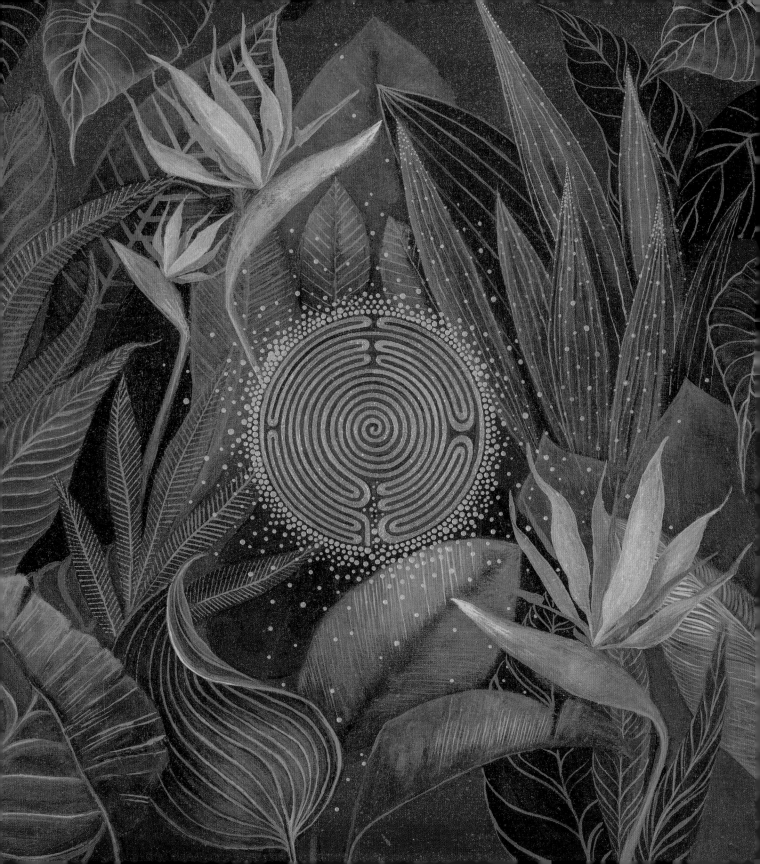

Let's get started

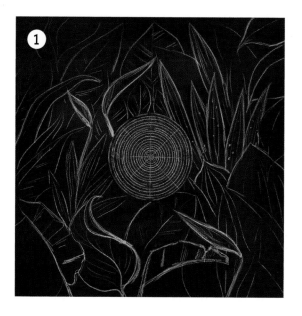 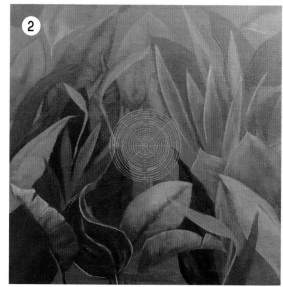

STEP 1

Cover the entire canvas in a deep dark green. Once the paint is dry, sketch the position of the leaves in white pencil. I constructed the labyrinth using a circular template, and sketched it with a white pencil (see Techniques).

STEP 2

Using muted colours, paint the leaves and decide on the shading. When you are happy with the overall colouring of the leaves, you can work on further shading the individual leaves.

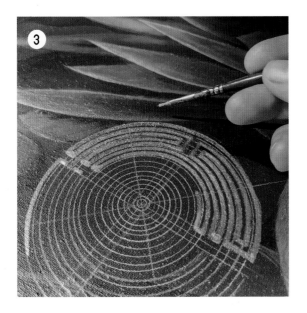

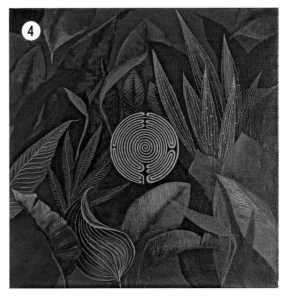

STEP 3

Paint over the labyrinth in copper and use a thin round brush. Work calmly and carefully; take your time, and consciously slow your movements. The more careful you are with the preliminary work, the better the results will be! As well as ensuring that the brush application is even, keep an eye on the gaps as well. They will show you whether you are working evenly or not. You can make the corners of the labyrinth angular or round.

STEP 4

Paint the veins of the leaves in a lighter shade of the colour you used for the leaves. Choose a shade that is light enough to create a fluorescent effect. Vary the density and movement of the lines, and let yourself be guided intuitively by the shape of the leaf.

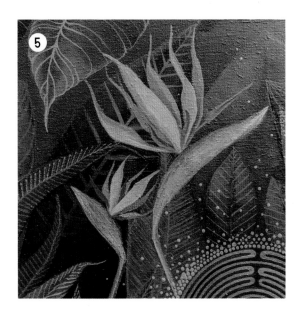

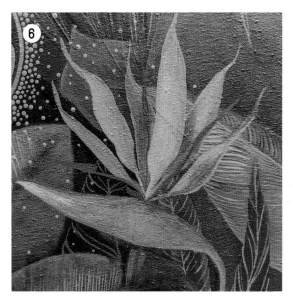

STEP 5

In this step, position the bird-of-paradise flowers. Keep the background dark in the areas where you want to paint the flowers, and omit the bright accents. This will really show the flower to the optimum effect.

STEP 6

Paint the petals at the back first in a darker, muted orange to create a sculptural effect. When they are dry, paint the petals at the front over them in a bright orange shade.

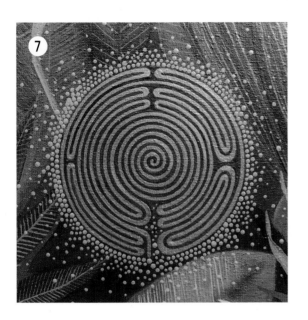

finished!

STEP 7

Finally, add lots of little dots around the labyrinth in copper. Make them denser around the outer circle of the labyrinth so they "float" irregularly away from the centre in all directions.

Tip

See Techniques to find out how best to create the dots. It's all about the consistency of the paint.

MYSTIC
Jungle

»ALL IS ONE«

This picture will take you into the world of jungle plants.
The bright moonlight makes leaves and flowers shine and
enchants the night. Shimmering light, delicate leaf veins
and ferns are brought to vibrant life by the dot technique,
taking the viewer into the mysticism of the plant world.
The golden labyrinth invites you to follow the path until
the mystery of the centre unfolds in front of you.

Materials

Canvas: 40 x 40cm (16 x 16in)

Brushes: Acrylic brushes made of synthetic
fibres; medium-sized flat brush for the base
coat; round brushes in various sizes for the
detail work

Acrylic paints: Palette ranges from
warm olives to rich shades of blue, green
and turquoise; violet and gold

Other: White and pink pencils for sketching

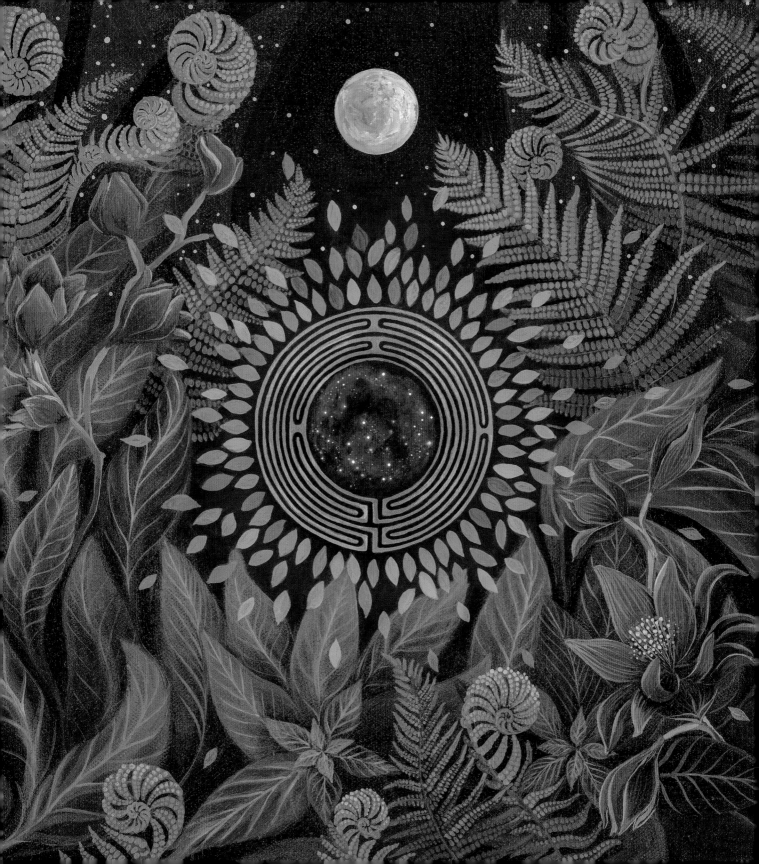

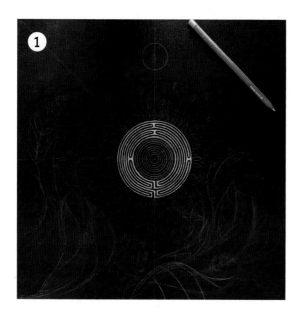

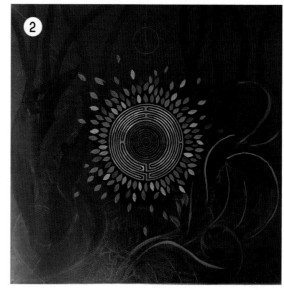

STEP 1

Start by covering the entire canvas in a deep midnight blue. This reflects the jungle at night, which is perfect for highlighting the greens and violets used later on. Sketch your composition in white pencil. Create the labyrinth (see Techniques) using a circular template, sketching it with the white pencil.

STEP 2

Paint the labyrinth in gold paint with a thin round brush. This requires the greatest care. Take your time, and enjoy the creative process. Without rushing, it becomes a meditative act. Next, add small, stylised leaf shapes arranged evenly around the labyrinth and positioned closely together. Then move further out, irregularly in all directions. They connect the symbol with the plant elements, and reflect the colour theme.

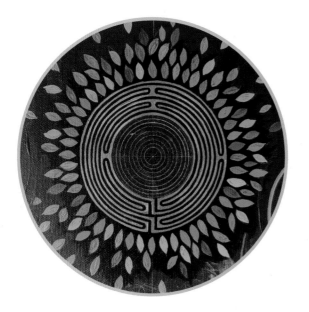

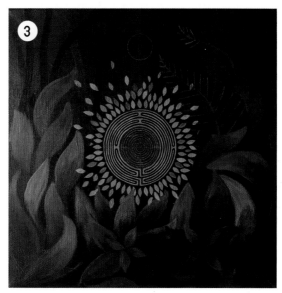

We'll zoom in a little closer so you can see the labyrinth and the arrangement of the leaves more clearly.

STEP 3

Now decide where you are going to place the leaves and sketch the shapes. Make sure that the leaves flow harmoniously around the centre, and don't look static. The colours become darker towards the edges of the canvas, so the eye is guided to the centre.

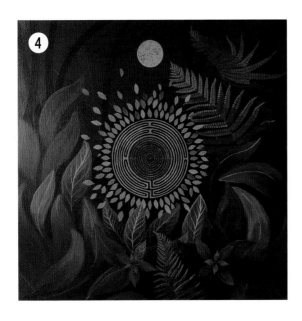

STEP 4

Now place the moon exactly on the centre axis. Don't use a pure white, but tint it slightly with the colours from the palette. This will allow the moon to integrate with the composition. The veins of the leaves and the dots of the ferns are the last accents to be added with a fine round brush. I used a lighter shade of the colour of the leaf for this. It creates a slightly fluorescent effect on the leaves, which makes them look mysterious.

Here's a more detailed look at the individual leaves of the ferns, so you can see how the dots are arranged.

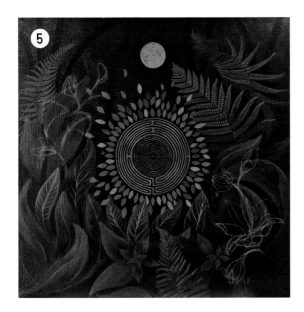

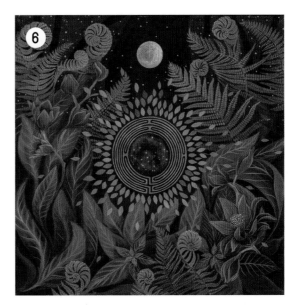

STEP 5

Once everything is dry, draw in the flowers with a pink colouring pencil. I did a soft sketch so I could make sure I was happy with the positioning and composition. It's also a good way to add more ferns (rolled-up leaves for example).

STEP 6

To finish, I drew the details such as the flowers, the stars and the cosmos at the centre of the labyrinth. These are the accents and highlights that add a very special finishing touch to the composition and make the picture glow. Consider the shape of the petals and shade them as appropriate in a slightly darker shade. Highlight the areas in the moonlight in a lighter colour to emphasise them.

ABOUT THE AUTHOR

Kathleen Hoffmann is an artist, illustrator and graphic designer with a degree in communication design.

Kathleen has been a freelance artist for 20 years. In addition to her projects as a graphic designer, she has also been a picture book illustrator and a painter in animated films.

In 2020, she moved to the Baltic coast with her family, where she is increasingly dedicating herself to her own artistic work. Her painting is based on the tradition of mandala art. In Kathleen's work, the harmonious properties of a mandala are complemented by the use of the filigree dot painting technique. Colours and shapes are combined to form balanced, pleasing images. The geometric shapes serve as a stage for weaving in illustrative elements. Poetic moments are combined with the power of the symbols.

Kathleen discovered her creativity in early childhood, amongst the plants and flowers of her family's plant nursery and her grandparents' vegetable garden. She still associates the scents, colours, moist earth and warmth in a greenhouse with a feeling of home, and this is strongly bound up with her approach to nature and the plant world. Kathleen's artistic vision is to make the magic of nature visible as precious knowledge lies within.

Kathleen's works are available to purchase as originals and as art prints. You'll find further information at:

Artist's page and online shop:
www.kathleenhoffmann.com

Instagram, Facebook and Pinterest:
@kathleenhoffmannart

THANKS

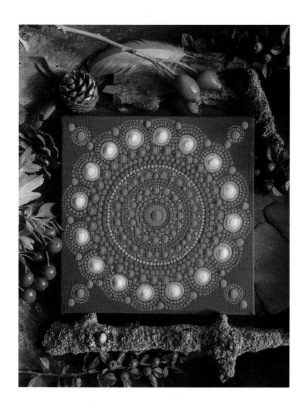

Thank you from the bottom of my heart, dear reader, for choosing this book. I hope I have been able to provide you with some useful information and, above all, inspiration and impulses for your own creative path.

I would like to send heartfelt thanks to the EMF publishing company for giving me the opportunity to make my art visible through this book and so reach other people who are interested in this type of art.

A special thank you also goes to my editor Nora Köpp, who chose me from the many great artists out there. Her professional support was the best help I could have had while we were working on this book. I felt very much encouraged and heartened by her.

And last, but by no means least: thank you to my wonderful husband, Axel Steinhagen, who is not only responsible for several of the photos in this book, but who also freed up a lot of valuable time so I was able to work on it.

A DAVID AND CHARLES BOOK
© Edition Michael Fischer GmbH, 2021
www.emf-verlag.de

David and Charles is an imprint of David and Charles, Ltd, Suite A, Tourism House, Pynes Hill, Exeter, EX2 5WS

This translation of MANDALAS MALEN, first published in Germany by Edition Michael Fischer GmbH in 2021, is published by arrangement with Silke Bruenink Agency, Munich, Germany.

First published in the UK and USA in 2022

ISBN-13: 9781446309636 paperback
ISBN-13: 9781446382202 EPUB
ISBN-13: 9781446382196 PDF

This book has been printed on paper from approved suppliers and made from pulp from sustainable sources.

Printed in China through Asia Pacific Offset for:
David and Charles, Ltd
Suite A, Tourism House, Pynes Hill,
Exeter, EX2 5WS

10 9 8 7 6 5 4 3 2 1

Cover, layout and typesetting: Silvia Keller
Editor and proof-reader: Nora Köpp
Photos: © Kathleen Hoffmann
Picture of the author: © Axel Steinhagen
Book spine: © Daria Moskvina/thenounproject (brush icon), inside: ©WinWin artlab/Shutterstock (decorative stars)

David and Charles publishes high-quality books on a wide range of subjects. For more information visit www.davidandcharles.com.

Share your makes with us on social media using #dandcbooks and follow us on Facebook and Instagram by searching for @dandcbooks.

Layout of the digital edition of this book may vary depending on reader hardware and display settings.